MW00618010

POSTCARD HISTORY SERIES

Fullerton

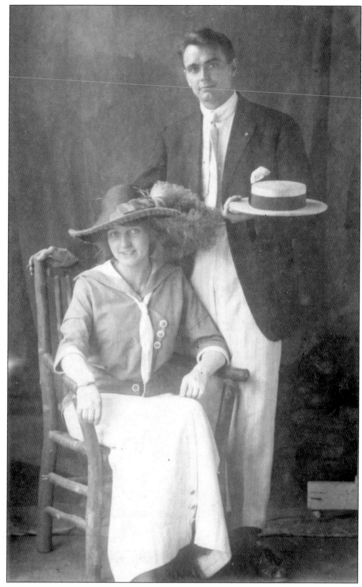

Taken in 1913, this real-photo postcard simply states, "Linda and Robert" on the back.

ON THE FRONT COVER: This early 1930s postcard features Spadra (later Harbor) Boulevard looking north from Commonwealth Avenue. The Chapman Building at 110 East Wilshire Avenue, pictured on the right, was then known as the Fullerton Department Store and was the tallest building in Orange County when it opened in 1923. (Courtesy of Tom Pulley.)

ON THE BACK COVER: Clifford S. Houston, a clerk with the J. W. Wallop general store in Anaheim, posted this often-reproduced postcard around 1910. The concrete-lined irrigation ditches, which also served as swimming spots for children, were the lifeblood of Fullerton's agricultural community. (Courtesy of Tom Pulley.)

POSTCARD HISTORY SERIES

Fullerton

Kathryn Morris, Debora Richey, and Cathy Thomas
Fullerton Public Library

ARCADIA
PUBLISHING

Copyright © 2007 by Kathryn Morris, Debora Richey, and Cathy Thomas
ISBN 978-0-7385-4788-6

Published by Arcadia Publishing
Charleston SC, Chicago IL, Portsmouth NH, San Francisco CA

Printed in the United States of America

Library of Congress Catalog Card Number: 2007924638

For all general information contact Arcadia Publishing at:
Telephone 843-853-2070
Fax 843-853-0044
E-mail sales@arcadiapublishing.com
For customer service and orders:
Toll-Free 1-888-313-2665

Visit us on the Internet at www.arcadiapublishing.com

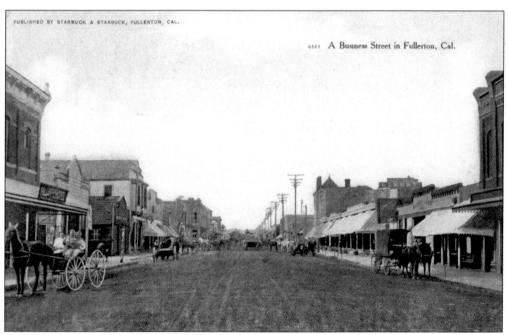

Taken around 1910 from the Santa Fe Railroad tracks, this postcard shows Spadra (now Harbor) Boulevard looking north. Initially the city developed north of the railroad tracks. The city streets were paved in 1914 after automobile drivers, whose maximum speed limit was 10 miles per hour, complained vociferously about poor driving conditions.

CONTENTS

Acknowledgments 6

Introduction 7

1. Advertising and Promotional Postcards 9

2. Holiday and Greeting Postcards 31

3. Real-Photo Postcards 41

4. German Postcards 85

5. Photochromes or Souvenir Postcards 97

6. Novelty and Specialty Postcards 115

ACKNOWLEDGMENTS

In compiling this book, the authors initially relied on the historical postcard collection housed in the Launer Room of the Fullerton Public Library. We would like to thank the Fullerton Public Library for allowing us to use this collection. We would also like to thank the following for sharing their postcards: Jorice Maag; Betsy Vigus; Photografx Worldwide, LLC; and the Fullerton Arboretum. And most of all, we would like to thank Tom Pulley for allowing us to incorporate postcards from his extensive collection. Over the years, Mr. Pulley has painstakingly collected the largest known personal collection of Fullerton postcards, and without the use of his extraordinary collection, this pictorial history of Fullerton would not be possible. In addition, for their unmatched, expert historical research assistance, the authors would like to thank Bob Linnell, Sharon Perry, and Anita Varela; for their excellent technological expertise, we would like to acknowledge Jeanette Contreras, Cheri Pape, Mark Masterson, and Marlon Romero.

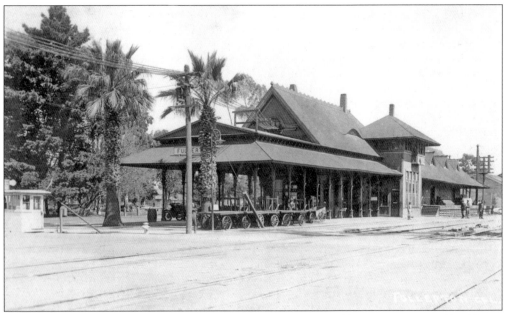

By the 1920s, most early California train depots had been replaced by Mission Revival buildings. An example is the Fullerton Santa Fe Depot (1888), shown in 1922, which became a popular spot for film locations needing a small-town station, including the 1925 silent film *Peacock Feathers*, based on the bestselling novel of the same name written by Temple Bailey (1885–1953).

INTRODUCTION

Over the decades, nearly all of the postcards received and sent by Fullerton residents were discarded after the messages were read. A wide variety of subjects—street scenes, scenic views, comic scenes, children, expensive dwellings, transportation, animals, etc.—were portrayed on these postcards, and this book is a tribute to those people who originally created the images and messages collected in this volume. Fullerton has a rich social history, and the postcards in this volume—advertising, greeting, historic, photographic, and novelty—reflect the society in which they originated. The pictures and messages stored on the fronts and backs of these vintage and contemporary postcards showcase the city's tastes, interests, and sentiments from 1891 to 2006 as Fullerton moved from a small agricultural community of scattered settlers to an urbanized city of over 130,000 residents.

The development and use of postcards by Fullerton residents mirrored what was happening throughout the United States. Although the first officially produced postal card went on sale in the 1860s, Americans did not show a marked interest in the use of postcards until the World's Columbian Exposition in Chicago in May 1893. At this exposition, government-produced postal cards and privately printed souvenir cards of grand buildings and lovely views sparked an immediate interest in the mailing and receiving of cards as well as the saving of cards as souvenirs. Until 1901, the federal government limited the use of the term "postcard" to only government-made cards. Privately printed cards were labeled "souvenir cards" or "mail cards." The federal government also limited writing to the front (picture side) of the card. The address side of the card was not for writing messages. Senders who wanted to add a greeting wrote in, above, or beneath the picture. This restriction did not inhibit postcard production, and millions of postcards were sent each year by Americans after the 1893 exposition. About three-quarters of these early cards were made in Germany, where producers had mastered the art of postcard printing and lithography. Cheap, mass-produced, and readily available, postcards gained universal acceptance, and the exchanging and collecting of postcards quickly became a worldwide craze. Individuals who became obsessed with collecting postcards were labeled "postcard pests," and social critics, who bemoaned the decline of the hand-written personal letter, referred to the fad as the "postcard plague."

On March 1, 1907, the U.S. Postal Service approved the use of the divided-back postcard. This change in regulations enabled the front to be used exclusively for the design, while the back was divided so that the left side was for writing a message and the right side for the address. This simple change ushered in the golden age of the postcard. By 1908, the U.S. Postal Service estimated that Americans were mailing 677 million postcards annually. The allowing of personalized messages coincided with the Eastman Kodak Company's invention of an affordable, easy-to-use, folding camera a year earlier. Anyone who owned the Folding Pocket Camera could have their photographic images printed directly onto card stock with preprinted, postcard-designated backs. From 1907 to 1930, Americans took millions of black-and-white snapshots of people, places, and things that they then turned into postcards and mailed around

the world. Although professional photographers produced many real–photo postcards and sold them in local shops, novices and amateurs were equally prolific, concentrating on local subjects that visually documented the social history of many cities and towns in America. In the 1930s, new technology allowed the printing of postcards on a linen–type stock paper. The linen postcards, popular from 1930 to 1945, were cheaper to produce and allowed for the use of bright and vivid colors. Around World War II, another new process, the photochrome or chrome, was invented for producing color postcards. After the war, it became the most popular form of souvenir for travelers.

Like the rest of America, it took Fullerton residents awhile to get on the postcard bandwagon. When the Amerige Brothers laid out the Fullerton town site in 1887, the first penny postcards sent and received by residents were primarily business, promotional, and appointment cards as the town struggled to gain an economic footing. Homes and ranches were scattered throughout Orange County, and businesses and traveling salesmen found postcards to be a cheap means of advertising their wares and services. Also popular from 1905 to around 1915 were holiday and greeting postcards, which were less expensive than traditional greeting cards, mailed in envelopes. Like many Americans, Fullertonians were swept up in the early 1900s by the growing fad of mailing, receiving, and collecting postcards. Drugstores, stationery stores, and newsstands, such as the Gem Pharmacy, Finch's Drugstore, and the Variety Store, had racks of postcards for sale. When there were not enough postcard views of Fullerton to sell, store owners George W. Finch, Herman A. Volkers, and Gus Leander had them made in Los Angeles, Chicago, and New York. However, it was William Starbuck, the owner of the Gem Pharmacy, who cornered the market, rapidly becoming the most prolific producer of postcards in the city. Many lovely, hand–tinted postcards were also produced in Germany.

Fullerton residents quickly succumbed to the craze for novelty postcards, in particular the leather postcard, which was at its peak in popularity around 1908. Residents joined postcard and pen pal clubs in which members exchanged cards with their pen pals, friends, and families. The local newspaper, the *Fullerton News Tribune*, would list the names of local residents interested in exchanging postcards, and starting in 1906, the *Los Angeles Times* ran a weekly listing ("The Correspondence and Postcard Exchange") for collectors from around the world. At the time, Los Angeles was the largest market for picture postcards, with more cards going out from local post offices than from any other city. Fullerton residents also signed on for postcard campaigns, mailing hundreds of cards in support of a particular cause. One example of postcard campaigning took place in October 1910, when the city formed a Post Card Week Committee to urge residents to send postcards to Congress in support of holding the 1915 Panama–Pacific Exposition in California.

The invention of the Folding Pocket Camera was a boon to the local postcard industry. Hundreds of residents took snapshots of local events and sites as well as themselves and members of their families. The real–photo postcards in this book (chapter three), taken by residents from 1906 to the 1940s, indicate what events, buildings, and attractions (the California Hotel, the Fox Theatre, Amerige and Hillcrest Parks, etc.) were the most important and popular with locals, providing a visual record of Fullerton during its peak years of development. The late 19th and early 20th centuries were particularly eclectic periods in the history of Fullerton architecture, and the postcards document the various schools of design popular with residents. Also immensely popular were hometown street and view scenes of busy streets, cozy neighborhoods, train depots, and horse-drawn carriages that illustrate how quickly Fullerton developed over the decades. After World War II, postcards featuring Fullerton dramatically declined, but businesses continued to mail advertising, coupon, and promotional cards, and souvenir cards continued to be sold around town. Fullerton postcards for sale often pop up on the Internet, indicating the large number of cards produced over the decades and the continuing interest shown in collecting them.

One

ADVERTISING AND PROMOTIONAL POSTCARDS

Advertising and promotional postcards developed from the popular Victorian trade cards of the 1880s and 1890s. Trade cards were small index cards that typically featured a colorful picture on the front side and advertising text on the backside. Local merchants and streetwalkers would hand them out free as a cheap and effective advertising tool for services and products. The first trade cards were printed in black and white, but these were gradually replaced by attractive and colorfully illustrated cards that featured all types of goods. Artistic trade cards were saved in scrapbooks, while others were exchanged with fellow collectors. When the federal government allowed picture postcards to be mailed in 1900, trade cards faded as businessmen quickly saw the commercial potential of mailing postcards to potential customers. The penny picture postcard allowed even the smallest business an effective and cheap means of advertising their wares and services, and by the 1920s, advertising postcards had become a part of American culture. At times, commercial cards were the most produced postcards, reflecting the rise of 20th century consumerism. Nightclubs, restaurants, hotels, motels, automobile dealerships, banks, utility companies, drive-ins, cinemas, car washes, and shopping locations in cities all handed out free postcards, many using them as coupons. Today advertising postcards are still in use, serving the same purpose.

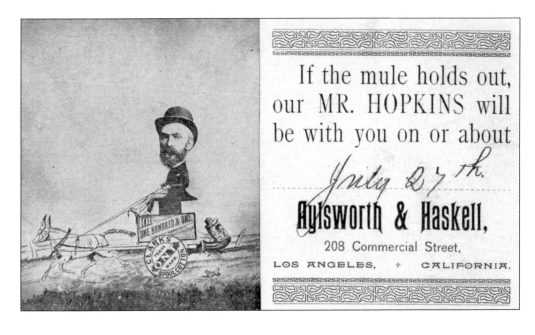

This announcement postcard was sent to Flora Starbuck to let her know that a Mr. Hopkins, a drummer or sales representative for Aylsworth and Haskell, a wholesale company in Los Angeles, would be arriving on July 27, 1891, to show her samples of Clark's spool thread. Flora and William Starbuck owned the Gem Pharmacy on Commonwealth Avenue, Fullerton's first drugstore. This postcard is an example of an undivided-back postcard, sold from December 24, 1901, until March 1, 1907, which did not permit writing on the address side. Postcards with a divided back were finally permitted on March 1, 1907, allowing the address to be written on the right side and the written message on the left side. (Courtesy of CSUF Arboretum Heritage House.)

ORANGE COUNTY NURSERY
AND LAND COMPANY (INC.)

———— DEALERS IN ALL KINDS OF ————
NURSERY STOCK AND
ORANGE COUNTY LANDS
Largest General Nursery in Southern California

We Publish an Annual Price List
It can be had by writing us at
FULLERTON, ORANGE COUNTY, CAL.

This early 20th-century postcard is reminiscent of a Victorian trading card. In 1897, Evert S. Richman (1861–1953) purchased the Orange County Nursery and Land Company, situated on 50 acres at 505 West Commonwealth Avenue. Using his bachelor of arts in scientific agriculture, Richman, a former professor, turned the company into the largest nursery in Southern California, amassed a small fortune, and then served as Fullerton mayor in 1912.

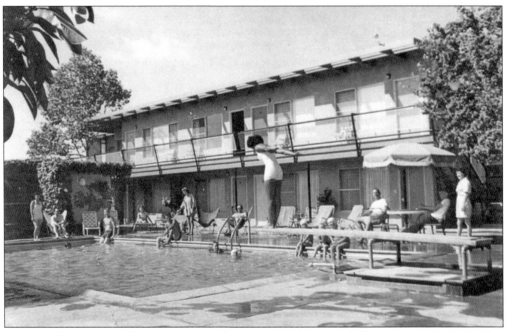

Now Tree's Country Place Apartments, the Country Place Motel, located at 1840–1850 West Orangethorpe, opened in the mid-1950s. The motel was one of a number that sprang up in the 1950s to accommodate increased tourist traffic in north Orange County. Disneyland had opened in 1955, Knott's Chicken Family Restaurant was serving 4,000 dinners each Sunday evening, and the Movieland Wax Museum was set to open in 1962.

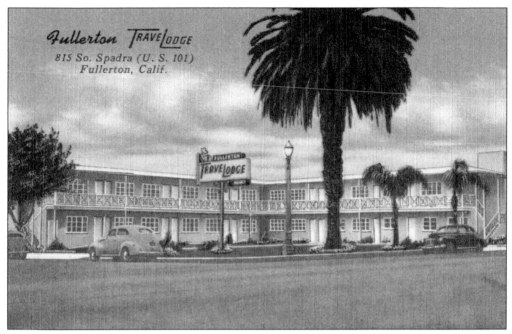

The TraveLodge Corporation, a motel chain based in El Cajon, opened this motel at 815 South Spadra (later Harbor) Boulevard in the late 1940s. This linen postcard was one of a number produced by the corporation to promote their motels.

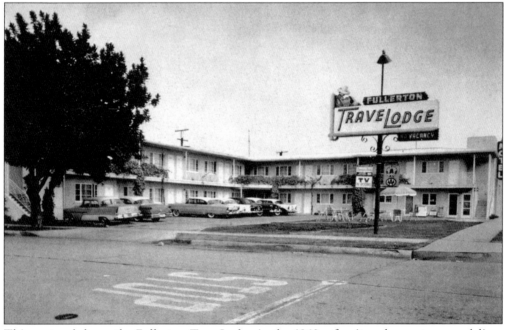

This postcard shows the Fullerton TraveLodge in the 1960s after it underwent a remodeling. The kid-friendly TraveLodge chain, which expanded into Canada and Mexico, targeted families by offering such amenities as in-room coffee service, free television, and outdoor swimming pools. It was sold to a British hotel chain in 1973.

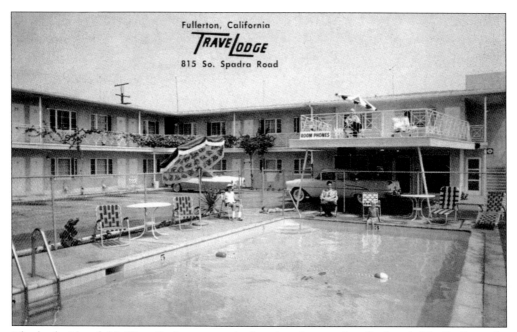

The back side of this TraveLodge postcard advertises the motel as "only a half mile from the new Riverside Freeway."

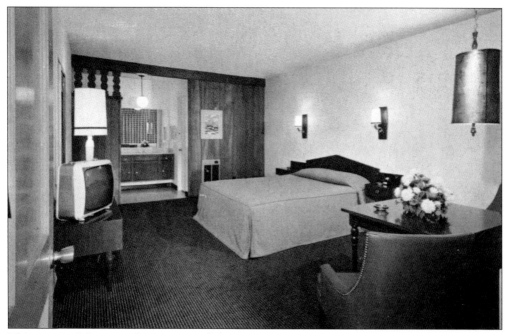

This postcard features the interior of the Hyatt Lodge, which opened its doors in 1962 as the Hyatt Chalet Motel, and is now the Willow Tree Lodge, located at 1015 South Harbor Boulevard. The backside of this postcard notes that the AAA-approved motel offered guests "room television and radios, custom décor, free ice, free coffee, room phones, oversized beds, ample parking, and valet service."

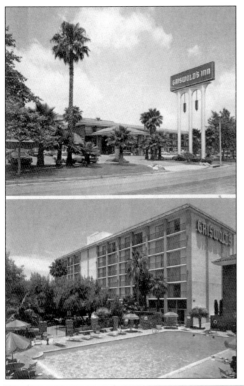

After great success at its original site in Claremont, Griswold's Restaurant, Inc. opened a Griswold's Inn in Fullerton at 1500 South Raymond Avenue in 1977. The facility, now the Four Points by Sheraton Hotel, featured 260 rooms, an outdoor heated pool, and Ruby Begonia's Restaurant and Lounge. Griswold's was originally founded in 1909 by George Griswold as a fruit stand and jam and jelly business.

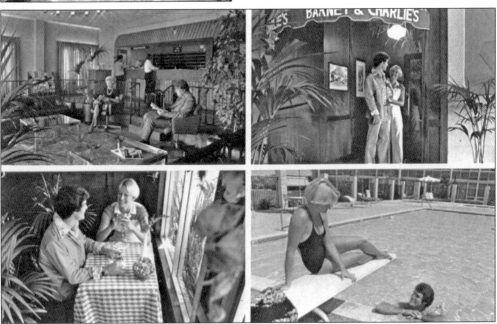

A young couple enjoy themselves in four separate areas of the newly opened Holiday Inn (222 West Houston Avenue), now the Wyndham Park Hotel. The 40,000-square-foot, $2 million inn, which featured 200 guest rooms, a dining room, coffee shop, and the Tambo de Oro Supper Club and Lounge, was constructed in 1974 by Ernest W. Hahn, Inc., and designed in a Spanish style by William Bond Jr. and Associates.

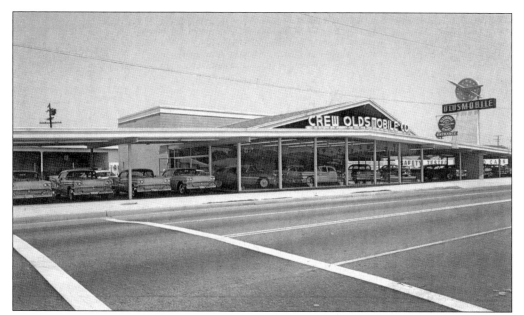

Cecil C. Crew (1894–1994) opened an Oldsmobile dealership in 1939 at 212 West Commonwealth Avenue and then built this new facility at 1325 West Commonwealth Avenue in 1957. A prominent Rotarian and former president of the Fullerton Chamber of Commerce, Crew also served as Fullerton mayor from 1958 to 1960.

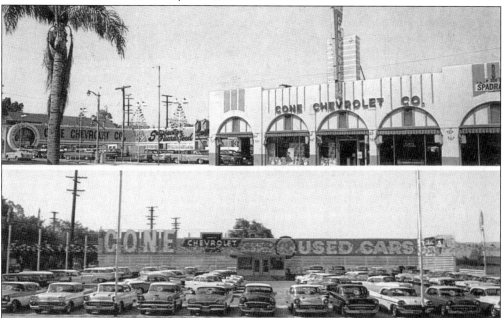

Originally Carroll D. Cone Chevrolet was located in Gardena. After the 1933 earthquake damaged the dealership, the company opened new quarters in Anaheim, and then later in Fullerton in 1939 with 15 employees when the city had a population of 10,000. New cars were sold at 320 South Harbor Boulevard (above); used cars at 400 West Commonwealth Avenue (below). In 1952, the Cones introduced driver training to Anaheim and Fullerton High Schools.

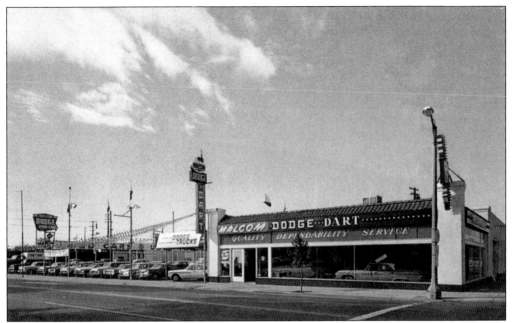

George and Muriel Klimpel purchased this Dodge dealership (201 South Harbor Boulevard) in the early 1950s and then sold it in 1962 to the City of Fullerton so it could build an underpass. The couple met on a blind date in 1927, married a year later, and lived long enough to celebrate their 75th wedding anniversary. Dodge introduced the Dodge Dart in 1960 as its entry into the growing compact car market.

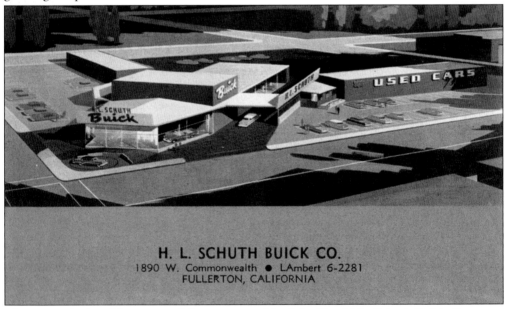

This unusual advertising postcard features a model of the Harold L. Schuth Buick Company at 1890 West Commonwealth Avenue, one of the most ultramodern automotive facilities in Southern California when it opened its doors on October 6, 1956. The facility extended over a 90,000-square-foot area and included three connected buildings. Movable equipment in the service unit allowed the company to service 37 cars at a time.

The McCoy and Mills Ford dealership sent this 1945 reminder postcard to Dale W. Neal (229 North Cornell Avenue), a member of the U.S. Navy, who was awaiting his new car. The dealership was founded in 1930 by brothers-in-law E. R. McCoy and Arlee Mills, who started selling tractor and farm implements before moving to top-of-the line cars and trucks.

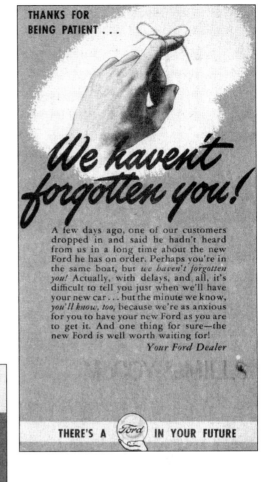

THANKS FOR BEING PATIENT . . .

We haven't forgotten you!

A few days ago, one of our customers dropped in and said he hadn't heard from us in a long time about the new Ford he has on order. Perhaps you're in the same boat, but *we haven't forgotten you!* Actually, with delays, and all, it's difficult to tell you just when we'll have your new car . . . but the minute we know, *you'll know, too,* because we're as anxious for you to have your new Ford as you are to get it. And one thing for sure—the new Ford is well worth waiting for!

Your Ford Dealer

THERE'S A *Ford* IN YOUR FUTURE

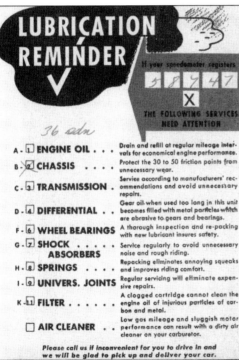

McCoy and Mills sent this lubrication reminder card to carpenter George Oswell (233 East Amerige Avenue) in April 1942. Reminder cards were an easy and quick way to notify customers that their cars needed service.

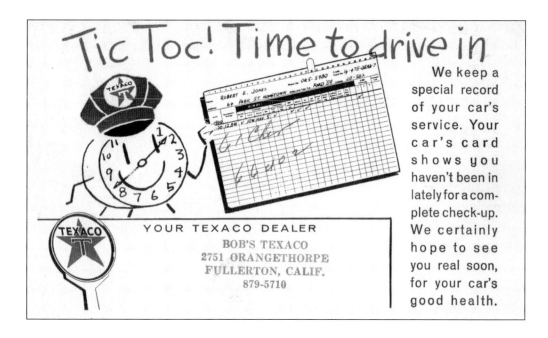

Texaco distributed these reminder cards to filling station owners, who would then stamp or write in their address on the bottom and mail them out to customers. Bob's Texaco mailed this card to Wallace J. Andrews (1556 West Olive Avenue), employee relations consultant for the Merchants and Manufacturers Association in Los Angeles, reminding him that his 1961 Chevy was due for a complete check-up.

YOUR METER READING OF CURRENT MONTH INDICATES CHARGE FOR GAS CONSUMED AS BELOW. THIS NOTICE SHOULD BE PRESENTED AT OUR OFFICE BELOW. ON OR BEFORE THE 10TH DAY AFTER DATE OF MAILING. SEE RULES ON REVERSE SIDE.
IF REMITTANCE IS SENT BY MAIL. PLEASE DETACH STUB AT RIGHT AND ENCLOSE WITH CHECK. YOUR CANCELLED CHECK IS YOUR RECEIPT AND NO OTHER WILL BE SENT.

SOUTHERN COUNTIES GAS COMPANY OF CALIF.
114 E. WILSHIRE AVE. FULLERTON. CALIF.
PHONE 302

PLEASE BRING THIS CARD WITH YOU

DATES OF METER READINGS	DATE OF MAILING	
JAN. 5 FEB. 5	FEB. 7 1934	FEB. 1934

PRESENT	PREVIOUS	100 CU. FT.	PRESENT CHARGE	PREVIOUS CHARGE	TOTAL
054	028	26✶	228		228✶

Form E41 Rem.

FULLERTON

MARIA TROY
E. CHAPMAN #2
FULLERTON CALIF.

615-6340

Rather than mailing a lengthy bill with a return envelope, utility companies in the 1930s and 1940s sent a simple postcard. This Southern California Gas Company bill was sent to teacher Maria Troy in February 1934. The bill total was $2.28. The front side of the postcard (below) spelled out the basic rules for nonpayment and bill disputes.

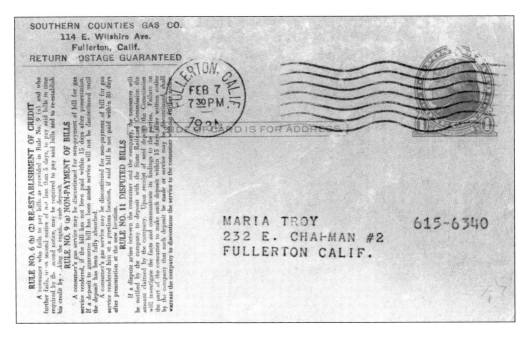

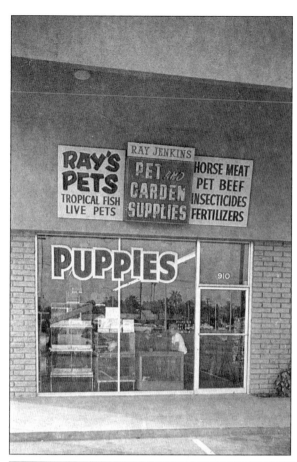

Ray Jenkins opened Ray's Pets and Garden Supplies (910 Williamson Avenue) in the early 1960s.

Owner Donald N. Schneider of Save-More Home Supply, located at 314 East Commonwealth Avenue, sent this card in the mid-1950s to Fullerton residents to promote the "smart, modern colors" of Du Pont's new Flow Kote rubber-based wall paint.

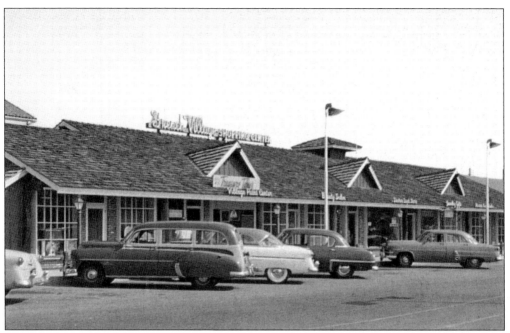

The French Village Shopping Center, located in the 400 block of West Commonwealth Avenue, opened in the early 1960s and featured a variety of small retail shops.

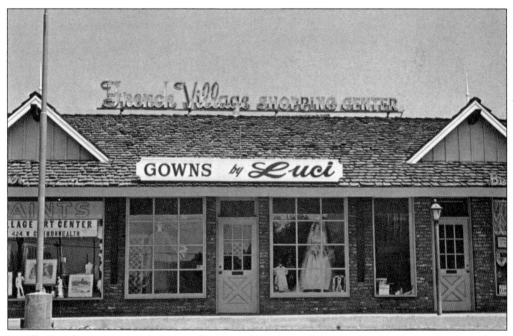

Lucille Pemberton opened Gowns by Luci (424 West Commonwealth Avenue), one of the shops in the French Village Shopping Center, in 1969. The dress shop featured wedding gowns, cocktail dresses, maid's outfits, and other custom-made designs.

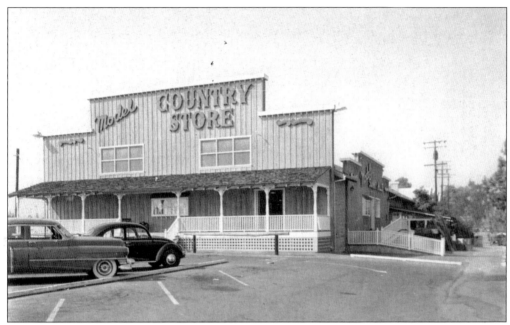

The Model Country Store (201 West Valencia Mesa Drive), which sold groceries and sundries, opened its doors on March 25, 1954. The store's architecture was designed to match the country theme of the Sunny Hills ranch area.

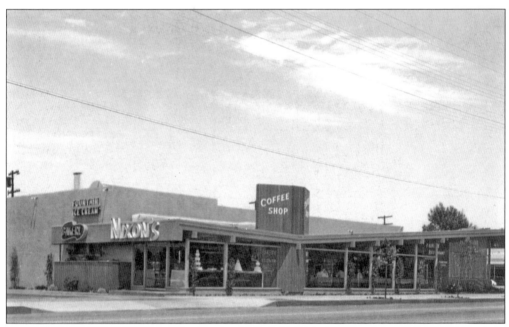

After opening a family restaurant and bakery in Whittier, Francis Donald Nixon (1914–1987) opened a second facility in Fullerton at 1501 West Commonwealth Avenue in 1956. Later he was forced to sell his businesses to pay off creditors. Donald Nixon's questionable business practices remained a lifelong embarrassment to his brother, Richard M. Nixon, and the president had his younger brother's telephone wiretapped in order to monitor his financial activities.

—LOOK FOR THE GOLDEN ARCHES® McDonald's

The first McDonald's in Fullerton opened on the corner of Orangethorpe Avenue and Brookhurst Road in 1969. The bearer of this coupon postcard was entitled to one free "100% beef" Big Mac, introduced in 1968. The oldest McDonald's in the worldwide chain of 20,000 restaurants, and the last one with the red–and–white stripped tile exterior, is located in Downey at 10207 Lakewood Boulevard; it opened in 1953.

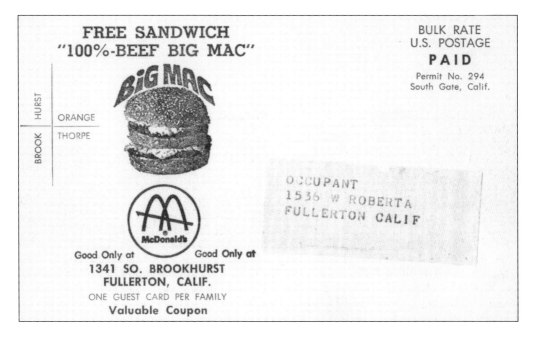

FREE SANDWICH
"100%-BEEF BIG MAC"

BULK RATE
U.S. POSTAGE
PAID

Permit No. 294
South Gate, Calif.

BROOK | HURST

ORANGE
THORPE

OCCUPANT
1536 W ROBERTA
FULLERTON CALIF

Good Only at Good Only at
1341 SO. BROOKHURST
FULLERTON, CALIF.
ONE GUEST CARD PER FAMILY
Valuable Coupon

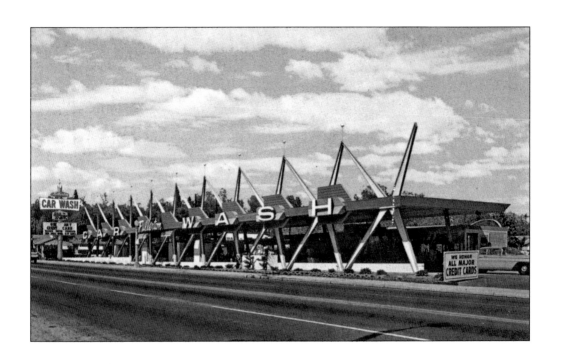

With this coupon postcard, Fullerton Car Wash (800 North Harbor Boulevard) would triple wash a car for 49¢. Free coffee was also available in the lounge. The futuristic and playful architectural style of the car wash, known as Googie, began in Southern California before fanning out to other areas of the nation, most amazingly in Las Vegas and Miami, and was at its peak in the 1950s and 1960s.

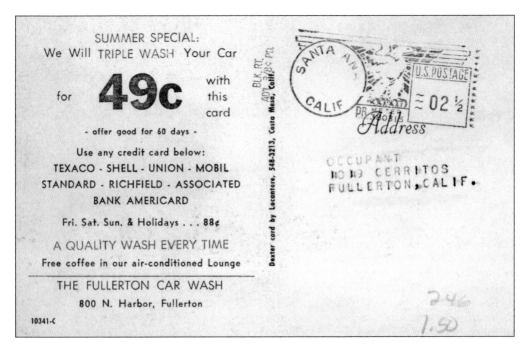

This coupon postcard was mailed July 11, 1968, to World War II veteran Angelo R. Ferraris (300 Malvern Avenue) by Sunny Hills Car Wash (100 West Bastanchury Road). The coupon postcard entitled Ferraris to a 49¢ car wash Monday through Thursday and to an 89¢ car wash Friday, Saturday, or Sunday. Coupon postcards have been popular since the early 1900s.

Named for Michael Liberty, the uncle of owners Jimmy and Frank Palmesino and the man who started them in their restaurant business, Michael's Inn (2425 East Orangethorpe Avenue) opened in 1962. The owner of this card would be served a free pitcher of the inn's "famous Almaden Wine." When the owners decided to change the menu, the restaurant name was changed at the same time to Angelique's.

Taking advantage of the smorgasbord craze hitting America, the Horn O'Plenty restaurant (1820 West Orangethorpe Avenue) opened its doors in the late 1960s.

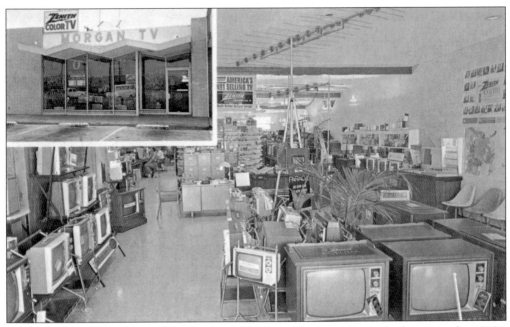

Established in 1952, Morgan TV Service (1322 East Chapman Avenue), shown in the 1960s, sold and serviced Motorola, Zenith, Voice of Music, Sony, and Fisher products. The postcard notes that Morgan TV "is one of the very few shops in Orange Co. to offer complete instrument alignment of color sets for optimum performance."

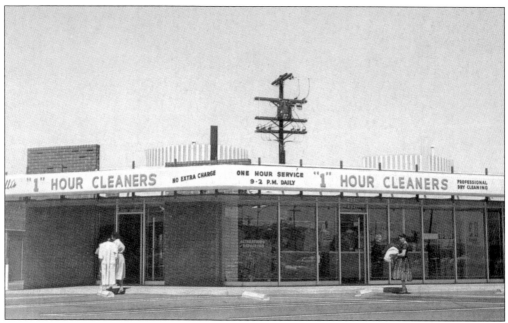

Located at 4321 South Santa Barbara Avenue, "1" Hour Cleaners offered one-hour dry-cleaning service "on request at no extra charge" plus a "convenient parking facility right in front of TWO entrances." The store's slogan was "personal care combined with professional skill."

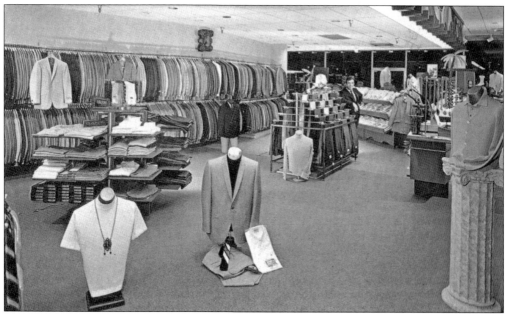

Fred Light, owner of the Lighthouse Store for Men at 212 Orange Fair Mall Shopping Center, used this 1974 postcard to advertise fashionable men's clothing: "The Brands you know plus the service you deserve from our wonderful world of color and fashion."

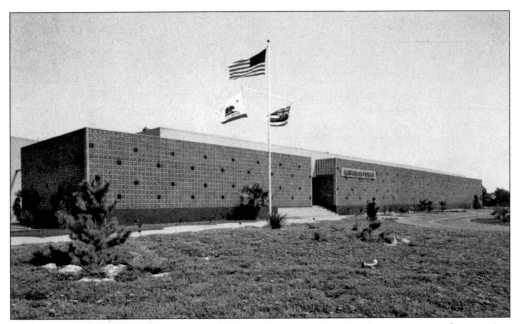

Pacific Hawaii Products Company mailed out this postcard in 1959 to announce the opening of their new processing plant (360 South Acacia Avenue) for Hawaiian Punch and Hawaiian Golden Punch. The company originally started in 1931 as Pacific Citrus Products at 120 West Amerige Avenue.

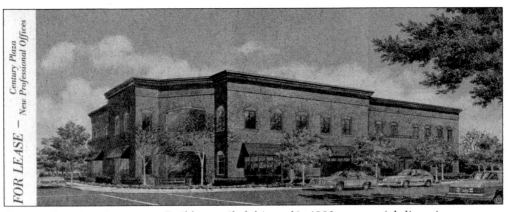

Century American Investment Builders mailed this card in 1983 to potential clients in an attempt to lease office space at the new Century Plaza, located at 150 East Commonwealth Avenue.

Unique Costume Rental (1153 East Elm Avenue) featured a Santa Claus outfit in this 1970s postcard. The rental company sold period costumes, including Tudor, Colonial, and French can-can, as well as such animal outfits as the eagle, hippopotamus, and two-man camel. Average rentals were $12.50–17.50, with more ornate ensembles costing $100.

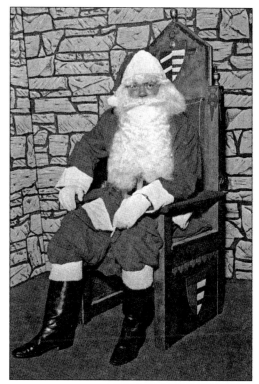

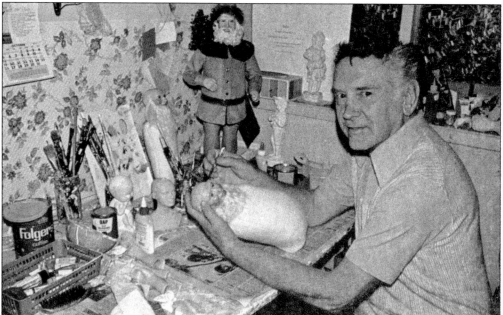

Unmarried and childless, internationally known sculptor Lewis Sorensen (1910–1985) started making dolls as a child. Shown in his studio, he worked entirely in wax. Sorensen, who moved to Fullerton in 1962, presented the Fullerton College Library with a complete set of his Presidential Doll Collection, only one of three complete sets featuring the presidents and first ladies from Washington to Reagan.

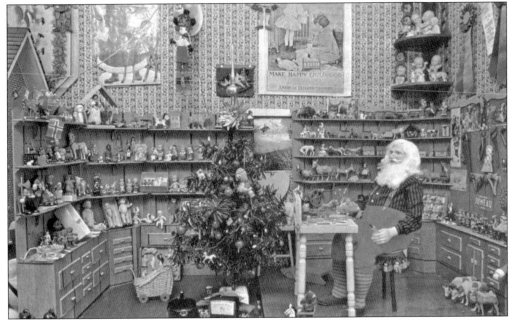

In the 1970s, Sorensen began work on his Original Santa Collection, which depicted the history of Santa Claus around the world. This postcard shows the workshop of the modern Santa Claus. The miniature toys are old and children played with most at some time. The tree lit up with miniature lights.

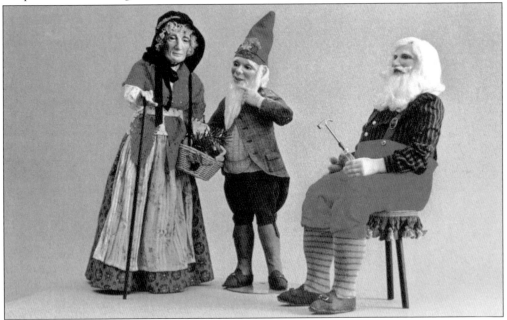

Also from the Original Santa Collection, this postcard features Bafana of Italy with her staff (left) out in search of the Christ Child, the little brownie from Denmark and Norway (center), and the modern old Santa (right). All the wax figures stand an average of 25 inches tall. Sorensen also sculpted wax figures for the Movieland Wax Museum (Buena Park) and San Francisco's Ripley's Believe It Or Not Museum.

Two

HOLIDAY AND GREETING POSTCARDS

The Golden Age of the holiday or greeting postcard occurred between 1900 and 1918. While greeting cards were available during this period, they could cost up to 10¢, at a time when most people made less than $10 a month, and the holiday postcard was a cheap alternative. Many of these early greeting postcards are graphically stunning, often featuring intricate embossing, expensive lithographic processes, beautiful artwork, superior inks, and on occasion, such additions as ribbons, feathers, silk, lace, and glitter. Valentine and Christmas cards were the most popular holiday postcards, but cards were also mailed out to celebrate St. Patrick's Day, Easter, Halloween, Thanksgiving, and New Year's Day. Holiday postcards were mailed out to celebrate other important days, such as Labor Day, Washington's Birthday, and Leap Year, but production of postcards and greeting cards for these special occasions declined, making them scarce and highly valued by collectors. Postcard artists relied on symbolism and motifs for each holiday, such as Santa, mistletoe, and holly for Christmas, using the same ones again and again from one holiday to the next. The holiday postcards in this chapter are dated from 1912 to 1914 and are primarily postcards sent to and from Fullerton residents.

A number of the greeting postcards in the Fullerton Public Library were mailed to Maude M. Lightner, including these two birthday postcards sent to her in December 1912. Maude married Russelles R. Lightner in Illinois in 1898, and the couple moved to Fullerton where he worked as a barber in the downtown Fullerton Barber Shop until his retirement. In 1912, the couple lived at 415 West Amerige Avenue but later moved to 129 West Brookdale Avenue.

Postcard artists used symbolism to express their thoughts, and flowers were frequently used to express the language of love, happiness, and loss. Each flower conveyed a specific message. The roses in this 1913 birthday postcard symbolize love, and the pansies represent loving thoughts and memories. Men and women who wanted to ensure their sweethearts loved them would carry or wear a pansy.

The violets in this embossed birthday postcard symbolize faithfulness.

This beautiful postcard of a young Pilgrim woman praying expresses the two themes common to Thanksgiving cards—peace and prosperity—conveyed by the wild turkey, the basket of fruits and vegetables, and the wheat harvest in the background.

This is No. 41 of a series of Christmas postcards produced on the East Coast.

These beautifully embossed 1912 Christmas postcards were manufactured in Germany. The holly has always been considered a sacred plant, and many churches in Europe had holly trees and bushes growing on their grounds. At Christmastime, the sharp evergreen leaves and red berries, which are always the largest and brightest in winter, were used to decorate church interiors.

This New Year's card features the poinsettia, the Mexican Christmas flower, named after Joel R. Poinsett (1779–1851), who served as America's first ambassador to Mexico from 1825 to 1829. He sent specimens of this indigenous plant with large scarlet leaves to the United States, where it flourished.

The four-leaf clover, mushrooms, and horseshoe on this German New Year's postcard are all symbols of prosperity and happiness. The "U" shape of the horseshoe was believed to ward off evil. In some cultures, the horseshoe points down to drain off evil, and in others it points up to hold good luck.

While holly has always been a holy symbol, it was also thought to ward off evil, and for that reason it often appeared on New Year's postcards. The clock ticking away time is a common image, as is the newborn child replacing Father Time, hoary with age.

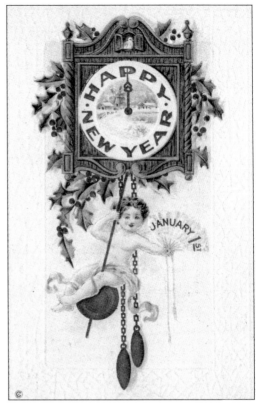

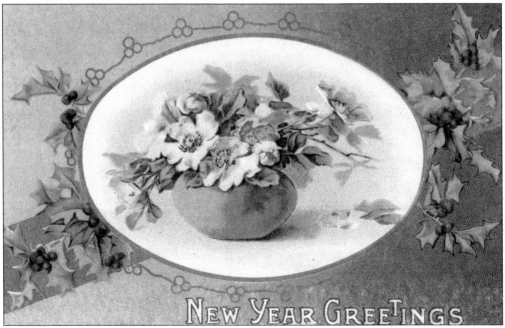

Wishes for good luck and happiness dominate New Year's postcards, which were particularly popular from 1900 to 1910. The pink roses symbolize the hope for perfect happiness in the upcoming year.

Chicks and rabbits were very common symbols for Easter postcards, but nothing was more popular than the egg, the universal symbol of life and rejuvenation. Postcard artists colored, adorned, and embellished Easter eggs with ribbons, flowers, leaves, and cherubs. The white lily, associated with motherhood, signifies purity and hope.

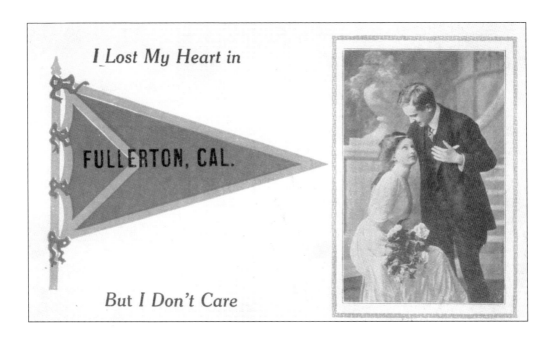

I Lost My Heart in

FULLERTON, CAL.

But I Don't Care

These two standardized valentine postcards, which feature the same couple in different romantic poses, could be purchased by drugstores and stationery stores where employees would then stamp the location into the pennant. Both cards were sent from a Fullerton admirer to Miss Mae Purser in Rivera, California, in 1913.

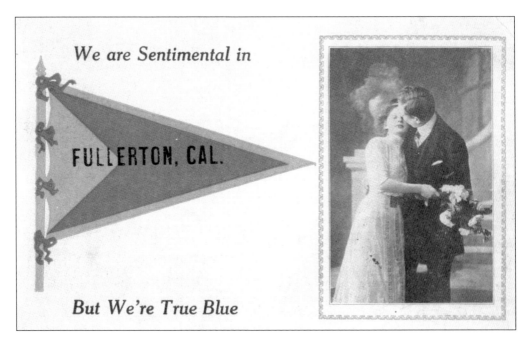

We are Sentimental in

FULLERTON, CAL.

But We're True Blue

To my Valentine

The earliest valentines were delivered by hand and were often accompanied by a gift, but with the arrival of the penny postcard, the production and mailing of valentines exploded. This lovely 1913 valentine postcard was manufactured in Germany and sent to Maude Lightner from a correspondent named George with the note, "I'm sending Cupid to you as he is freezing here. Hope you'll treat him fine."

Three

REAL-PHOTO
POSTCARDS

Unlike commercially printed postcards, which were reproduced hundred of times, real-photo postcards are actual photographs printed on photograph paper with a preprinted postcard back. Early-20th-century technology made it possible for Fullerton residents to turn their photographs into postcards to be mailed to friends and loved ones throughout the world. Similar to the current digital photography craze, Kodak's 1906 introduction of an affordable, easy-to-use, portable camera that printed photographs onto heavy card stock inspired ordinary Americans to produce thousands of postcards of everyday life. Rather than snapshots of popular tourist spots, many of the images are of families, homes, and personal items, along with such local phenomena as fires, floods, and parades. Some of the images are black-and-white photographs, but others are hand-tinted in great detail using beautiful colors. On occasion, real-photo postcards, taken by professional photographers, would be sold as souvenirs in local drugstore and stationery shops, such as Fullerton's Gem Pharmacy, Finch's Drugstore, and the Variety Store. These photographers often identified the subject of the postcard by writing the street, town, or homeowner on the negative, making it a permanent part of the photograph, but a large number of real-photo postcards from this period remain unidentified. Real-photo postcards were popular between 1907 and 1930, but Fullerton residents continued to make them into the 1940s. Because real-photo postcards are often one-of-a-kind, they are highly valued by collectors and historical societies.

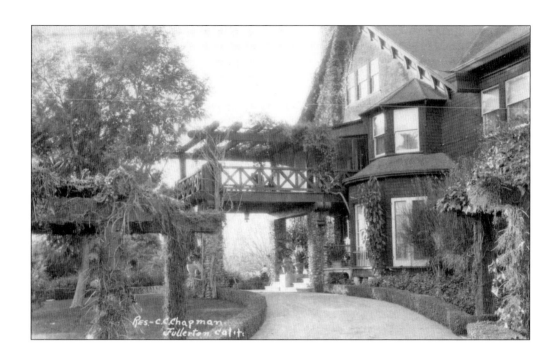

Although designed for family comfort, the Charles C. Chapman residence was nevertheless the largest home in Orange County when it was constructed in 1904. A fire destroyed the dwelling, located on what is now the northeast corner of Commonwealth Avenue and State College Boulevard, in 1960. Mailed in March 1913, the bottom postcard shows the private road leading into the Chapman residence and ranch.

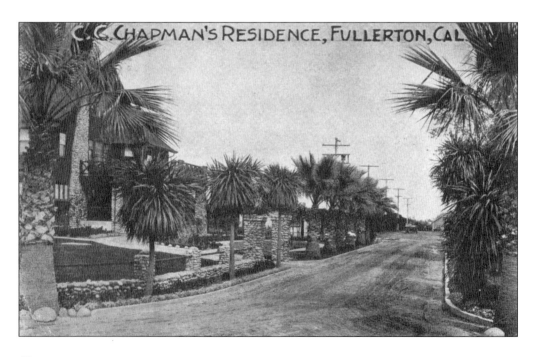

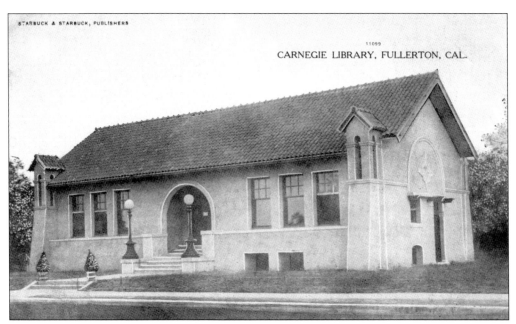

11099
CARNEGIE LIBRARY, FULLERTON, CAL.

Constructed at a cost of $10,000, Fullerton's first library building opened to the public in 1907. William Starbuck, owner of the Gem Pharmacy, sent this local postcard to the Curt Teich Company of Chicago (1898–1976), one of the oldest and largest postcard companies in the United States, to be reproduced.

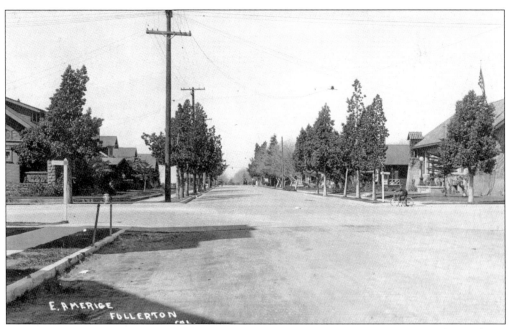

Incorrectly identified as East Amerige Avenue, this 1910 snapshot shows the 100 block of East Wilshire Avenue. The Carnegie Library, now the location of the Fullerton Museum Center (301 N. Pomona Avenue), is on the right.

Taken in the mid-1930s, this snapshot is the west 200 block of Malvern Avenue looking east toward Spadra (Harbor) Boulevard. Park commissioner J. G. Seupelt (1877–1961) started planting street trees throughout the city in 1919.

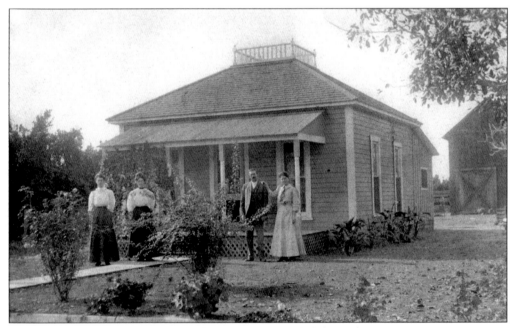

On December 25, 1907, the McCart family, shown, mailed their Christmas greetings to George A. and Alice Ruddock (207 West Commonwealth Avenue). George, the son of wealthy town pioneer Charles Ruddock, was part owner of Ruddock and Fuller, a real estate and insurance company in Fullerton.

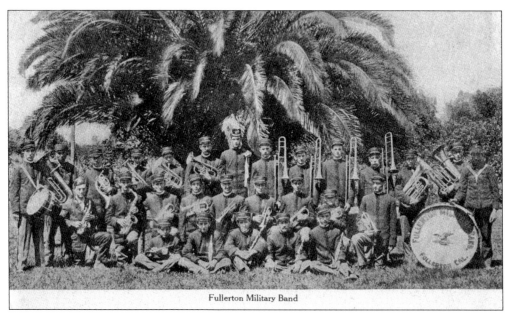

Fullerton Military Band

The Fullerton Military Band, shown here in 1908, was reorganized and whipped into shape by H. W. Shriver in 1906. Shriver later organized the Fullerton Military Band Orchestra. The total cost of the instruments shown was $2,580, a hefty price at the time. This postcard was published by Finch's Drugstore, located at 110 North Spadra Boulevard, owned by George W. Finch.

Residence Scene, Fullerton, Cal.

Mailed on April 29, 1909, by two Fullerton visitors, this snapshot showcases the home of the wealthy Richman family (541 West Commonwealth Avenue). Modern apartments were later added to the residence, marring the home's lovely exterior. Evert S. Richman's advertising postcard is on page 11.

This postcard features the Davis residence located on Truslow Avenue. J. F. Davis, an agent with the Santa Fe Railroad, constructed the dwelling around 1898.

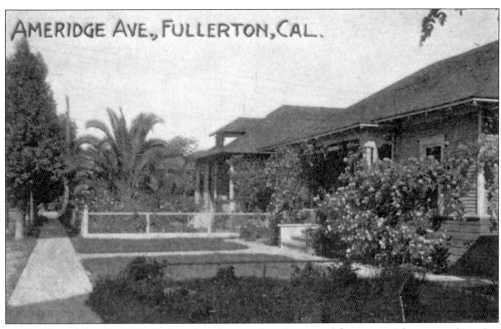

Mailed September 7, 1911, this Los Angeles–produced postcard features residences on Amerige Avenue (incorrectly identified as Ameridge Avenue).

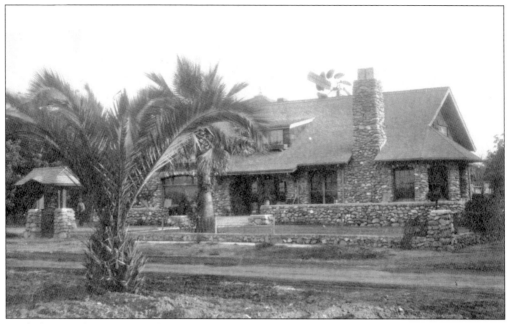

Mailed September 27, 1912, this postcard features an affluent residential dwelling in Fullerton.

Taken in the 1920s, this postcard features a very typical residence for the time, located at 441 East Commonwealth Avenue.

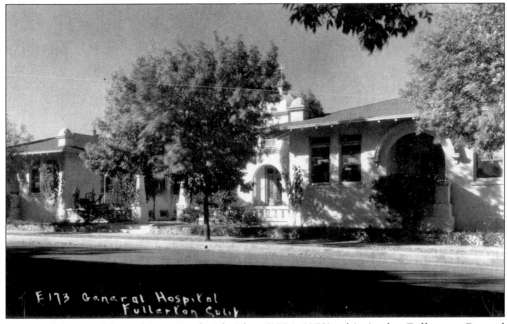

Designed by notable architect Frederick Eley (1884–1979), this is the Fullerton General Hospital (201 East Amerige Avenue), the city's third hospital. Constructed in 1913, the hospital featured the latest technology, up-to-date operating rooms, and a Swedish masseur. All of the patient's rooms opened to the outside.

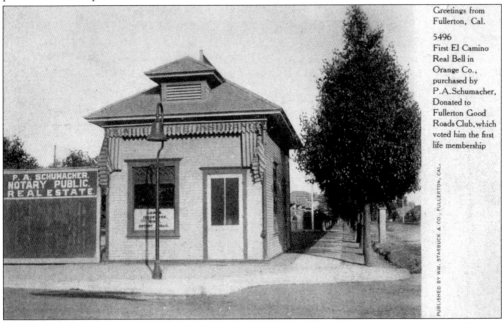

Greetings from Fullerton, Cal.

5496 First El Camino Real Bell in Orange Co., purchased by P.A.Schumacher, Donated to Fullerton Good Roads Club, which voted him the first life membership

PUBLISHED BY WM. STARBUCK & CO., FULLERTON, CAL.

Justice of the Peace Peter A. Schumacher (1843–1933) purchased Orange County's first El Camino Real Bell (shown in the 1910s), located in the 200 block of North Spadra (now Harbor) Boulevard. The cast iron bells, designed to mark the Spanish padres' trail, weighed over 100 pounds, with the iron representing the iron will of the men who made the first roads in California.

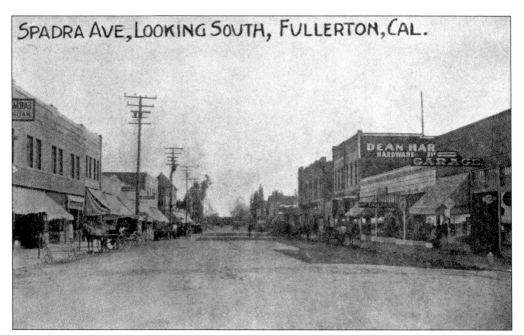

SPADRA AVE, LOOKING SOUTH, FULLERTON, CAL.

Mailed March 28, 1913, by Tom Vickers of 236 West Amerige Avenue, this is Spadra (later Harbor) Boulevard looking south. The Dean Block (1899–1901), named for Dean Hardware on the right at 111–113 North Harbor, is Fullerton's oldest surviving commercial block.

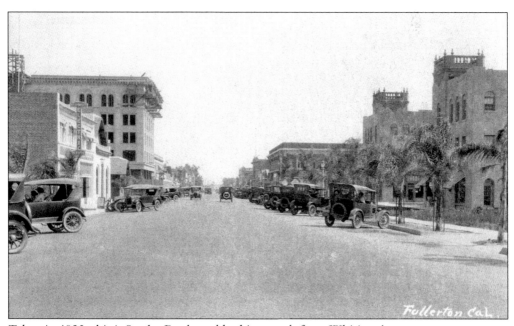

Taken in 1923, this is Spadra Boulevard looking south from Whiting Avenue.

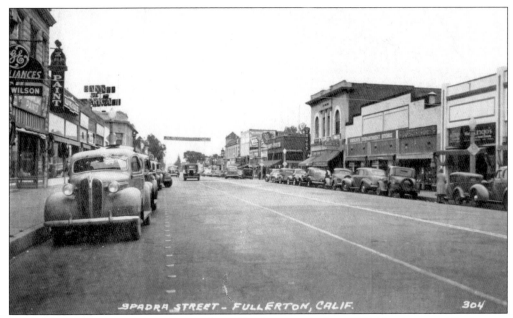

Taken in the 1940s, this is Spadra Boulevard looking south from Wilshire Avenue. The banner running across the boulevard announces the upcoming orange festival.

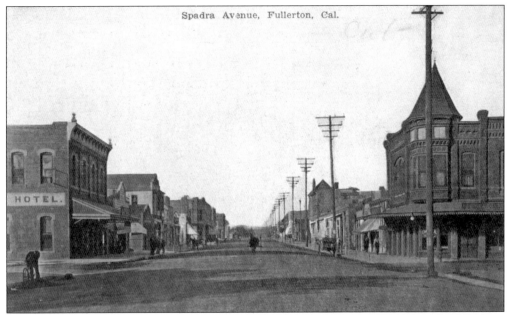

Taken around 1910, a lone buggy drives down Spadra Boulevard (facing north). The Fullerton Hotel on the left and the Commercial Hotel on the right were modest lodgings for the time.

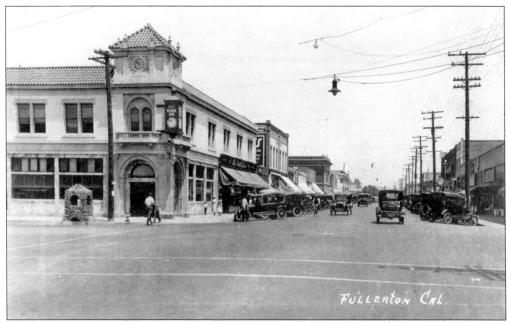

Taken in the 1920s, this snapshot shows Spadra Boulevard looking north from Commonwealth Avenue. The First National Bank, which opened in 1919, is on the left. The value of land was rising in the downtown area, with landowners charging $800 per front foot on Spadra.

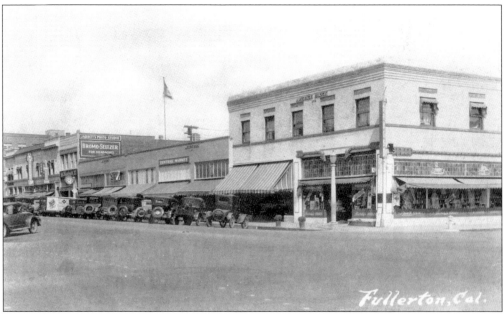

Taken in the 1920s, this is Spadra Boulevard looking northeast. Town founder George Amerige (1855–1947) and his wife, Annette (1868–1961), used the second story of the building on the right (105 East Commonwealth Avenue) as their home from 1920 to 1938.

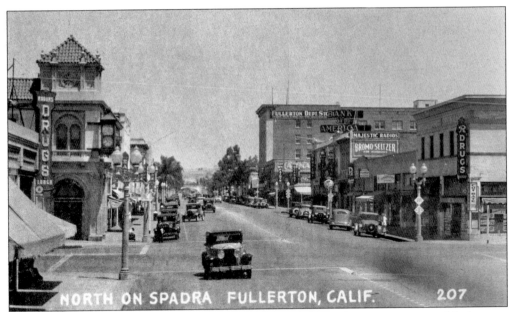

Taken in the 1930s, this is Spadra Boulevard looking north from Commonwealth Avenue. Traffic had greatly increased in the downtown area, but there was still no traffic signal at the corner of Spadra and Commonwealth Avenue.

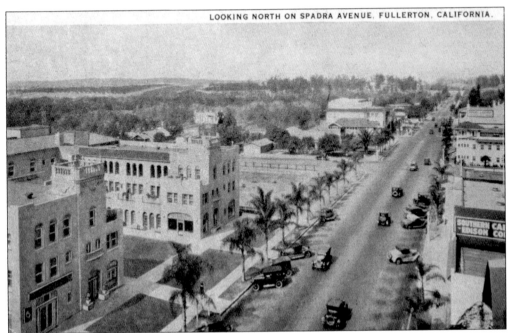

Mailed May 4, 1934, by a Mr. Crist to a Miss Mildred Burns in Rockford, Illinois, this is Spada Boulevard looking north. Taking a cue from the Mae West movie *She Done Him Wrong*, released in 1933, Crist wrote, "Come up and see me some time."

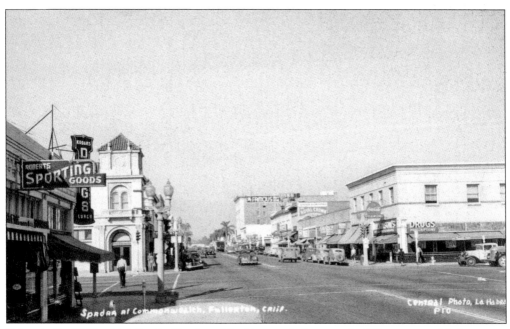

Taken in the 1940s, this is Spadra Boulevard looking north from south of Commonwealth Avenue.

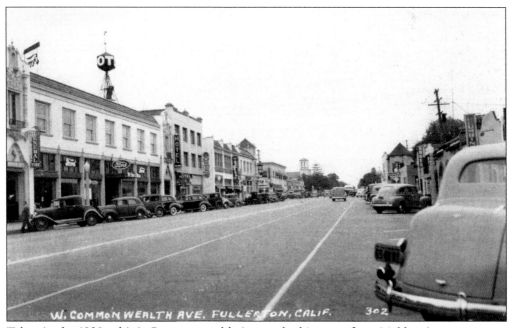

Taken in the 1930s, this is Commonwealth Avenue looking east from Malden Avenue.

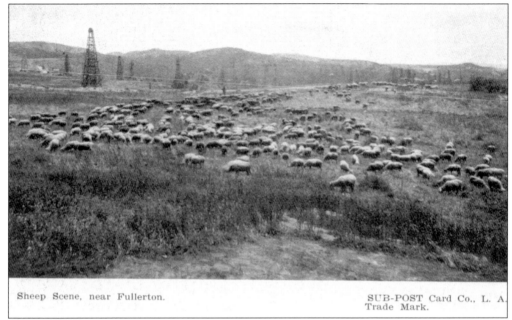

Sheep Scene, near Fullerton.

SUB-POST Card Co., L. A. Trade Mark.

Sheep and oil derricks commingle on Bastanchury Ranch. Oil was found at relatively shallow levels in the hills outside Fullerton around 1890, sparking an oil boom. Domingo Bastanchury (1839–1909) eventually leased 3,000 acres to the Union Oil Company and another 2,400 to the Murphy Oil Company.

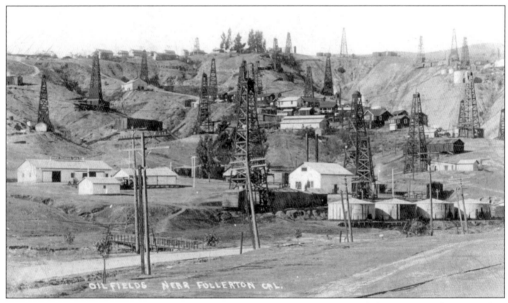

OIL FIELDS NEAR FULLERTON CAL.

On March 28, 1921, oil worker Eddie sent this postcard of the oil fields near Fullerton to his sister in Phoenix, Arizona. Some of the largest oil wells in the United States were found in the hills north and northeast of Fullerton.

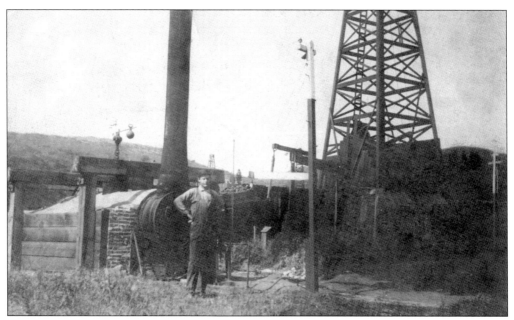

This postcard shows oil worker H. Handel (Petroleum Development Company) on the job in 1909. At the time, 375,000 barrels were being pumped a month, and oil was selling for $1 a barrel, a sum that convinced many sheep and cattle ranchers to convert their agricultural land to oil fields. The wells brought sudden riches to land owners in Fullerton, Brea, and La Habra.

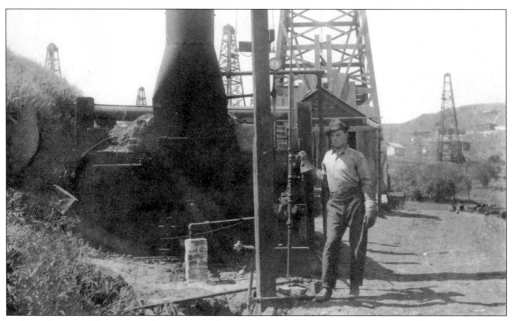

Oil worker D. Thompson, living in Fullerton, mailed this postcard of himself and the well he was operating to his pal Elmer Terry in Ohio on May 14, 1910. Thompson notes to his friend that he has "a dandy job."

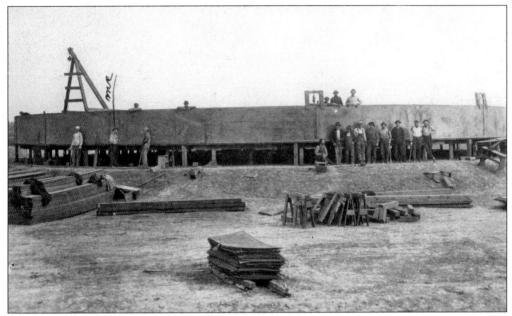

On December 17, 1913, Jack Fitzgerald mailed this postcard of himself (second from left under the "me") and other oil workers to friends in San Francisco. Fitzgerald was then staying at the Fullerton Hotel (123 South Spadra Boulevard), and was one of a number of transitory employees hired to work in the booming petroleum industry.

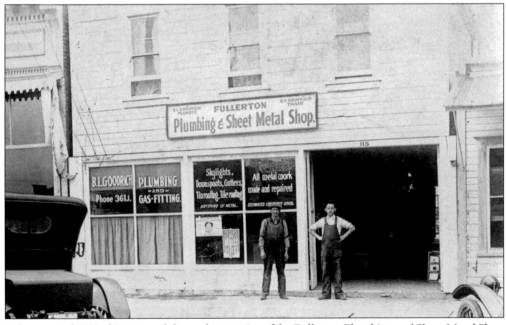

Taken around 1919, this postcard shows the exterior of the Fullerton Plumbing and Sheet Metal Shop (115 West Commonwealth Avenue), owned by Gustav H. Grunwald and Burleigh L. Goodrich. The business specialized in plumbing, heating, ventilation, sheet metal work, automobile radiators, and fender repairs. A poster supporting World War I is in the display window.

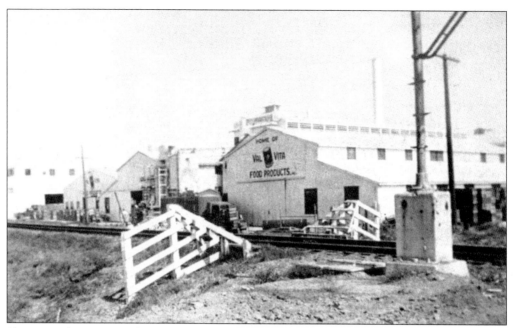

Shown in the 1920s, Val Vita Food Products, Inc., a small citrus plant located at Brookhurst Road and Commonwealth Avenue, was purchased for $35,000 in 1932 by future industrialist Norton Simon (1907–1993), who turned the plant into multinational Hunt-Wesson Foods.

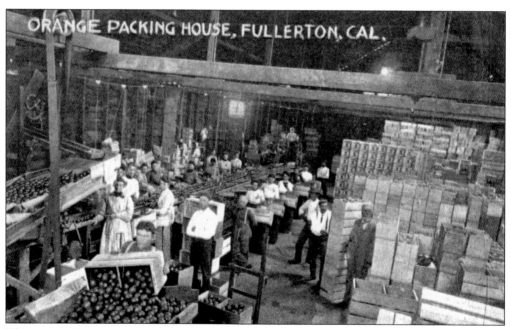

This postcard, reproduced by a number of postcard companies, shows the inside of an orange packinghouse around 1920. At the start of the 1900s, walnuts were Fullerton's largest cash crop, but by the 1920s the production of walnuts was outstripped by the production of oranges. Herman A. Volckers originally printed the postcard for his shop, the Variety Store (212 North Spadra Boulevard).

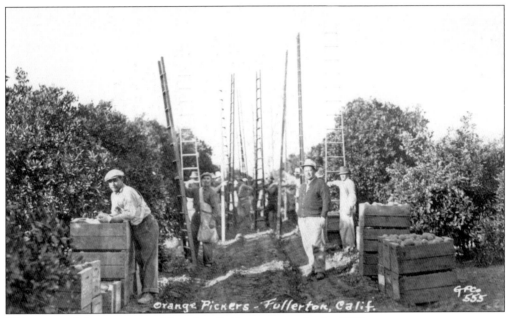

This postcard shows orange pickers in a Fullerton grove in the 1930s.

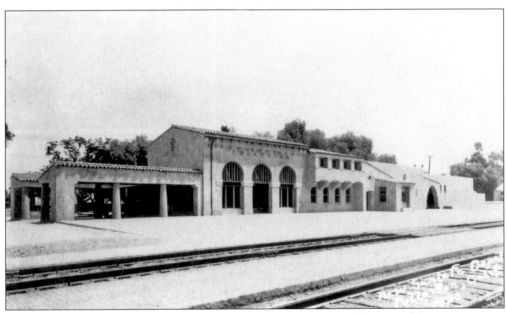

Dedicated July 3, 1930, the second Santa Fe Depot was built 100 feet east of the 1888 station. The Spanish Colonial Revival building was constructed by local contractor E. J. Herbert at a cost of $50,000. This snapshot, taken shortly after the depot opened, shows the building vacant, but it was actually a bustling spot for passengers and produce shipments.

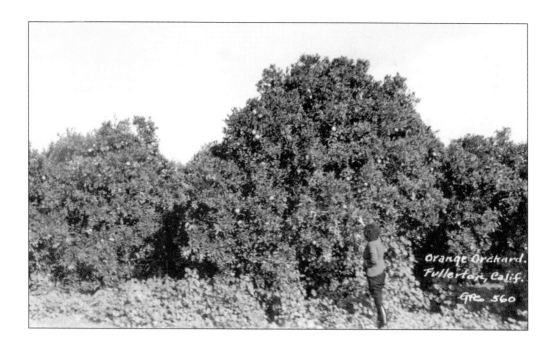

Taken in the 1940s, these two real-photo postcards feature Fullerton palm trees and orange orchards, two popular subjects of Fullerton photographers.

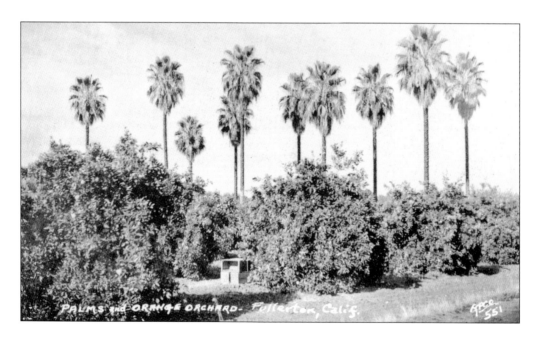

The back of this postcard reads, "This is a picture of one of Orange County's famous paved highways through a walnut orchard to the oil wells where over $12,000,000 worth of crude oil and natural gas was produced in 1914. Walnuts and oil are important, but that's not all for which this section is noted. For full particulars apply to the Chamber of Commerce."

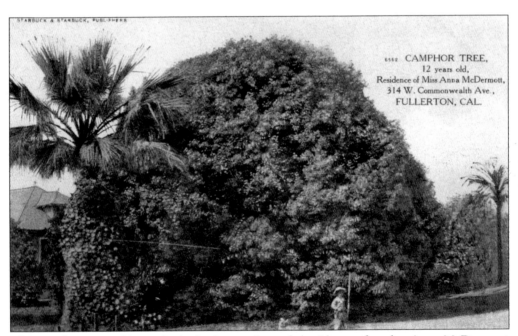

The camphor tree and house in the background was the residence of teacher Anna McDermont (incorrectly identified as McDermott) in 1910. McDermont's obituary described her as a "progressive woman." In 1913, she published a well-publicized pamphlet, "A Glimpse of My Trip around the World," a detailed narration of her travel experiences.

When Amerige Park (formerly Commonwealth Park) opened to the public in 1919 after it had closed for landscaping, its beautiful natural scenery rivaled any park in Orange and Los Angeles Counties. In addition to lush plantings, the park featured a wading pool, gazebos, benches scattered along walks, and swings and monkey bars for children.

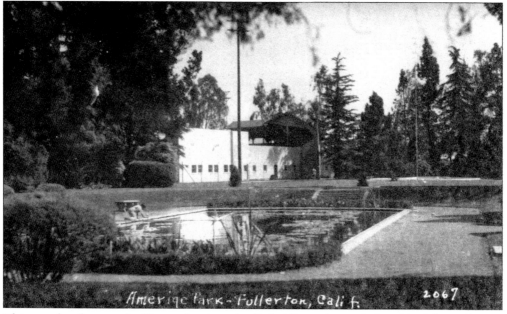

This snapshot features the lily pond at Amerige Park. The park was designed by Johann George Seupelt (1877–1961), Fullerton's first park commissioner, who also laid out Hillcrest Park in 1922. Seupelt was the most formally educated landscaper in Orange County and was also employed by nearby cities for various projects.

This postcard features one of the nine lights that lit Amerige Park at night. The park was immensely popular with Fullerton residents, who flocked to the park as soon as it was relandscaped. In the evenings, visitors were often treated to band concerts.

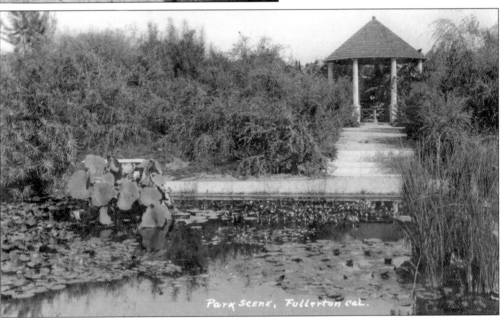

Park Scene, Fullerton Cal.

This postcard shows the lush vegetation that Seupelt was able to quickly install on the Amerige Park grounds. He imported plants and trees from vacant land in surrounding cities and started a city nursery to grow additional vegetation. Seupelt also planted Fullerton's first street trees in 1919.

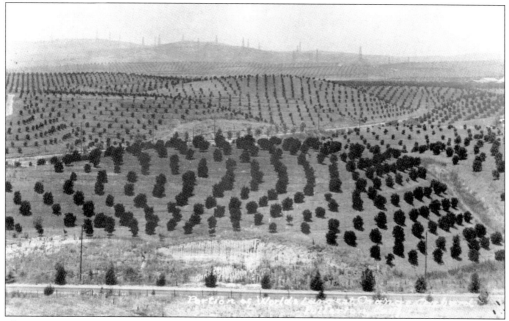

Shown in the late 1920s is the Bastanchury Ranch citrus orchard, then the largest in the world. In June 1929, the Bastanchury family held a contest to name the land, which had been variously known as the Union Oil lands, Touseau Hills, and Skyline Drive. The winning name was Sunny Hills Ranch. The Great Depression and over-expansion forced the company into receivership in 1931.

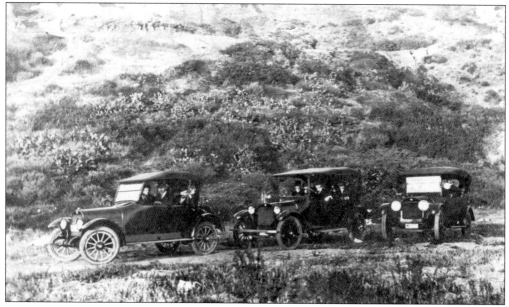

On June 8, 1919, Charles D. Scales (123 East Maple Avenue), an employee of the Benchley Fruit Company, mailed this postcard to his mother in Paonia, Colorado. Charles and his wife, Ethel, along with a passenger, are seated in the first car on the left.

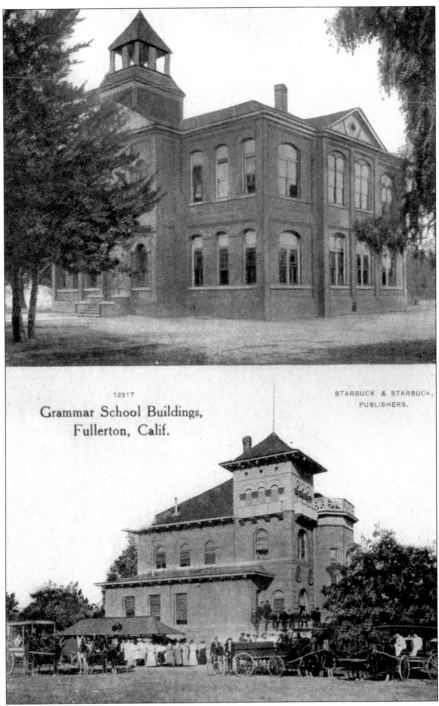

Grammar School Buildings,
Fullerton, Calif.

129·7

STARBUCK & STARBUCK,
PUBLISHERS.

Mailed May 11, 1909, this postcard features Fullerton's first two school buildings. The above building served as the Fullerton Grammar School, opening its doors in 1889. The building below housed the Fullerton High School (1895) until it moved to new quarters on Commonwealth Avenue for the start of classes in the fall of 1908. Later it was purchased by the elementary school district and used for classrooms.

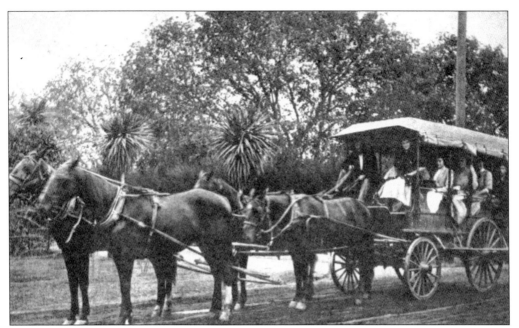

In the 1900s, rancher George B. Key took this photograph of a horse-drawn school bus that was used to transport students from the Placentia area to Fullerton Union High School (Key's son Will is in the back row, far right). In 1989, the Orange County Historical Society converted the photograph into a postcard to commemorate the Orange County Centennial. Key's historic Placentia ranch is open to the public.

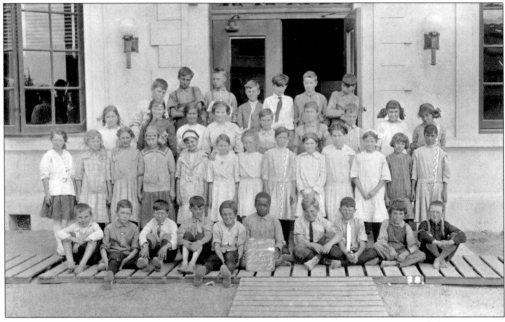

Taken on September 23, 1913, this postcard features the fifth-grade class of the Fullerton Elementary School, located on the corner of Wilshire and Lawrence Avenues. Enrollment was slowly rising at the grammar school. In 1910, the average daily attendance was 243, and by 1914 it was 450.

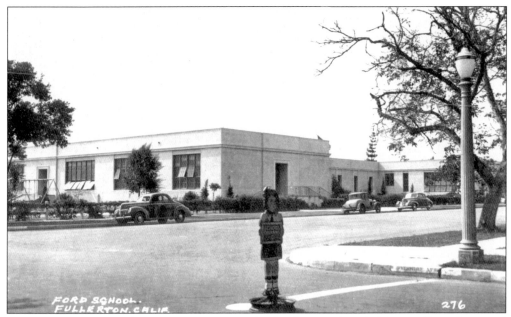

Located at Ford and Chapman Avenues, Ford School opened in 1920 as Fullerton's second grammar school. The wooden crossing guard (Safety Sally) was the brainchild of the Orange 20–30 Club in 1939, and the warning signs quickly became popular across the nation. The original figures, which were dressed like schoolgirls or uniformed policemen, were made of plywood, but after drivers demolished them, they were replaced by metal ones.

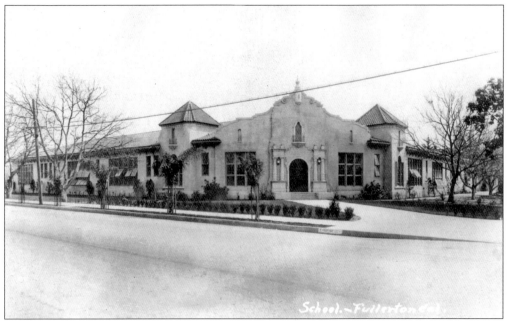

The front entrance of the Chapman School (1921), located on the southeast corner of Lemon Street and Chapman Avenue, was demolished after the 1933 Long Beach earthquake, but other parts were rebuilt and additional rooms added, allowing the school to stay open.

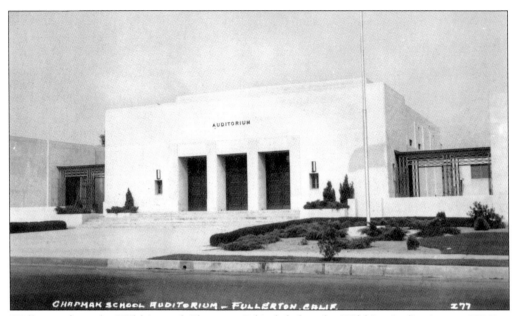

Walkways from the Wilshire and Chapman Schools led to the Wilshire Auditorium at 315 East Wilshire Avenue. Designed by notable architect Donald Beach Kirby (1905–1980) in 1936, the Wilshire Auditorium was the first Public Works Administration (PWA) building constructed in Orange County during the Great Depression. The auditorium is now part of Fullerton College.

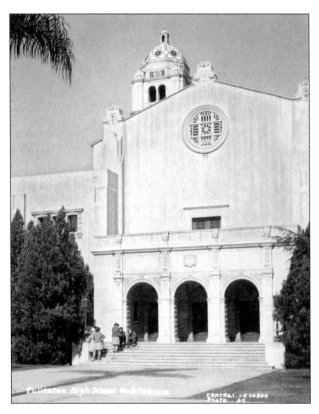

After several years of planning by the city's leading citizens, Plummer Auditorium at 201 East Chapman Avenue was built in 1930 and quickly became a cultural and educational center for high school and junior college students, as well as the community at large. Architect Carlton M. Winslow (1876–1946) was instrumental in establishing Spanish Colonial Revival as the preferred architectural style for public buildings in Fullerton in 1919.

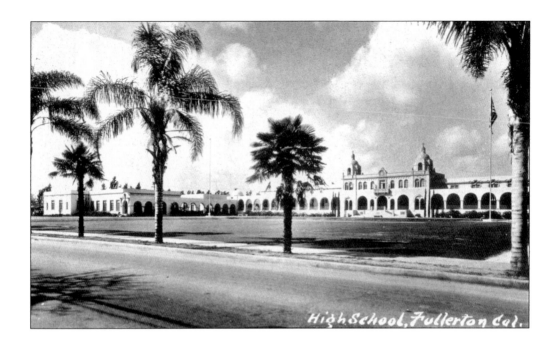

The present Fullerton Union High School campus (201 East Chapman Avenue) is actually the third site for the city's first high school. In 1922, the initial group of wooden-frame bungalows was replaced with 13 separate buildings erected in a quadrangle on 22 acres. A 1929 visitor with a two-hour stop at the nearby train depot mailed the above postcard.

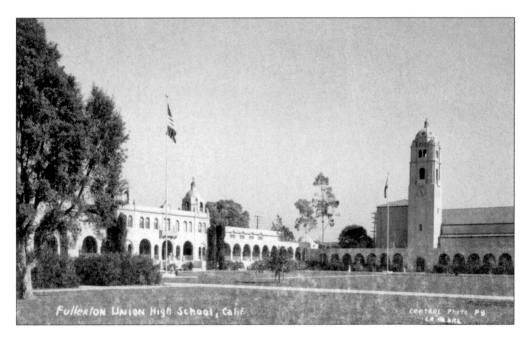

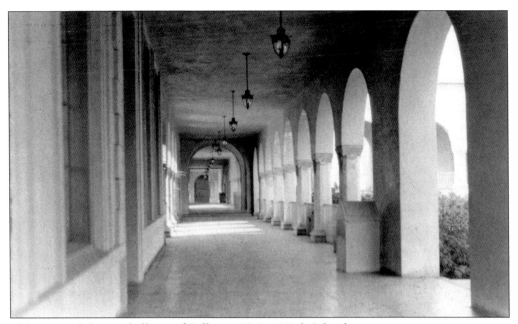
This postcard shows a hallway of Fullerton Union High School.

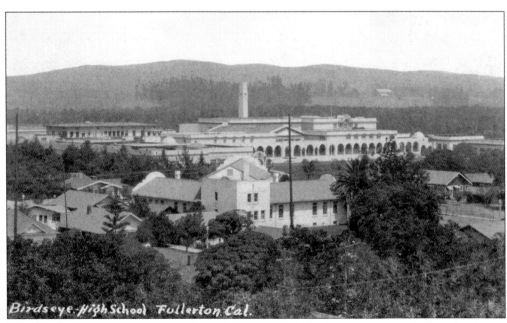
Taken in 1934, this postcard shows a bird's-eye view of Fullerton Union High School with farmland still in the background.

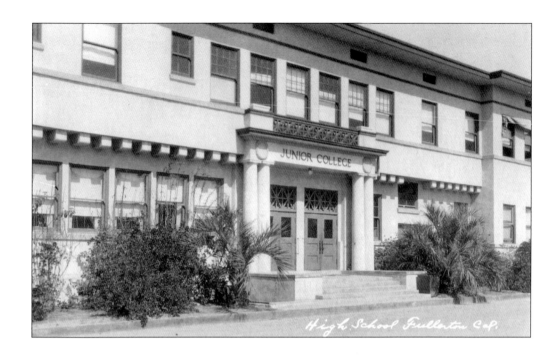

On April 25, 1913, the Fullerton High School Board of Trustees established Fullerton Junior College as a department of the high school. The college became a separate institution on March 31, 1922. The above postcard features the entrance to the new college. The postcard below shows the junior college building (later demolished) on the high school campus around 1925.

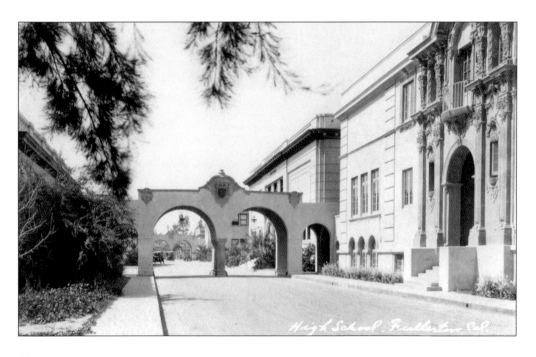

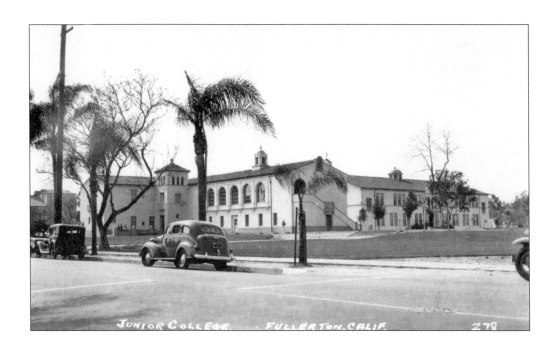

In 1934, the Fullerton Junior College Board of Directors purchased a 14-acre parcel of land located adjacent to the high school, and the first buildings for the campus were completed in 1938. These two real-photo postcards feature the campus in the 1940s. Fullerton Junior College, as it was known from 1913 to 1972 until it became Fullerton College, is the oldest continuing community college in California.

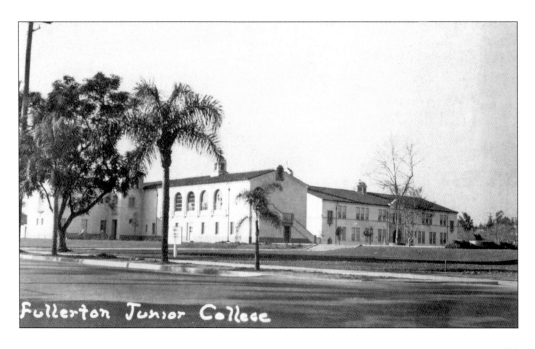

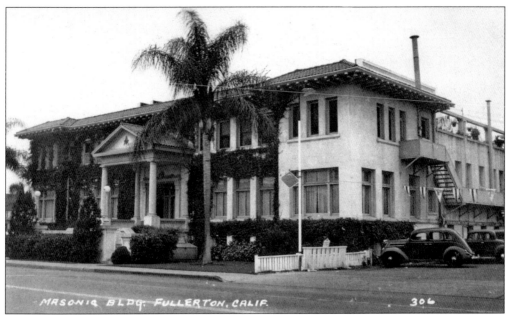

Constructed in 1920, this building, now the Spring Field Banquet Center (501 North Harbor Boulevard), was the second Masonic Temple in Fullerton, taking the place of the much smaller facility still at the northwest corner of Harbor Boulevard and Amerige Avenue (see page 87). This snapshot shows the scenic landscaping that once enhanced the downtown area.

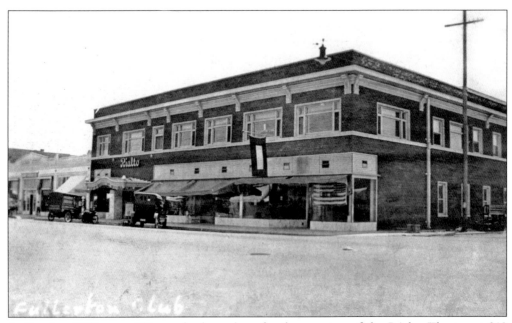

In October 1917, over 400 people showed up for the opening of the Rialto Theatre at 219 North Spadra Boulevard. The theater featured silent films from 1917 to 1927. Owner Harry Lee Wilber (1875–1946), the father-in-law of C. Stanley Chapman, went on to manage the Alician Court Theatre from 1925 to 1929.

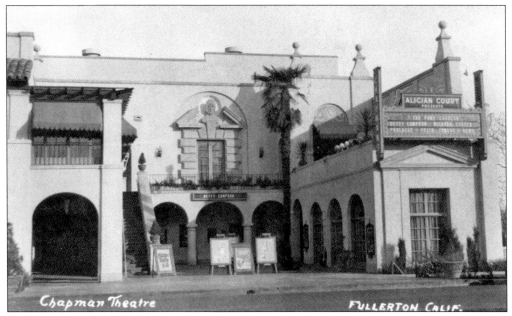

Shown shortly after it opened in May 1925 is C. Stanley Chapman's Alician Court Theatre, now known as the Fox Fullerton Theatre. Designed to resemble an Italian Renaissance palace, the Alician Court was the smallest one of three courtyard theatres (the other two were the Egyptian and Chinese Theatres in Hollywood) built by the contracting firm of Meyer and Holler, Inc.

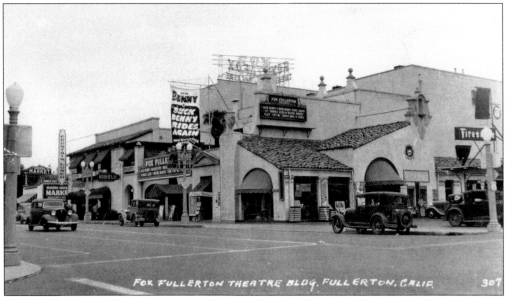

This 1940 postcard features the Fox Theatre after the Firestone Tire and Rubber Store was added on the south side in 1929. The Firestone building was the first formally planned super service station in Fullerton and one of the few one-story buildings still in the downtown area. The movie being shown, *Buck Benny Rides Again*, featured comedienne Jack Benny in a spoof of Western clichés.

A visitor to Hillcrest Park in May 1945 mailed this postcard to a friend in Arcadia, noting on the back how lovely the park looked. The park, landscaped by park commissioner J. G. Seupelt, who also landscaped Amerige Park, was constructed on 35.6 acres purchased by the City of Fullerton in 1920.

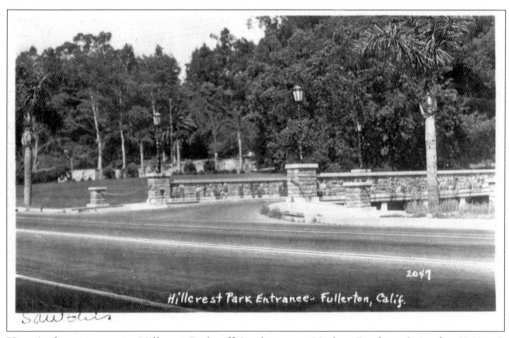

Here is the entrance to Hillcrest Park off Spadra, now Harbor Boulevard, in the 1940s. A visitor to the park has noted, "Saw this" in the lower left corner.

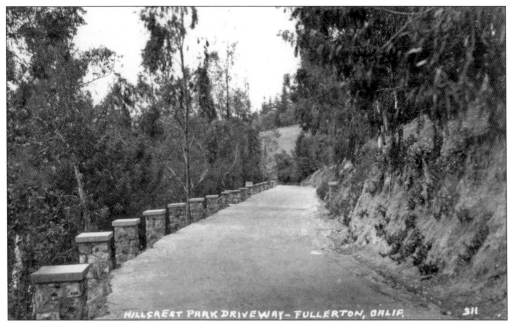

This 1940s postcard shows Hillcrest Road in Hillcrest Park after it was paved and after Work Projects Administration (WPA) workers added handcrafted flagstone during the Great Depression. The original roads for the park were laid out in 1923–1924 using a mule team, a plow, and a Fresno scraper.

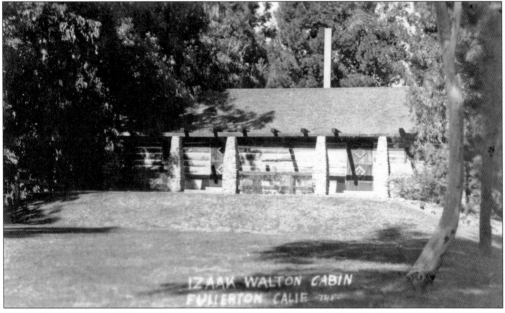

Centrally located in Hillcrest Park, the rustic Izaak Walton Cabin, Fullerton's only cabin, was constructed of discarded telegraph poles in 1931 at a cost of $165. WPA workers added the stonework shown on this 1940s postcard. A fire on December 24, 1990, destroyed the original cabin, but it was reconstructed in 1996.

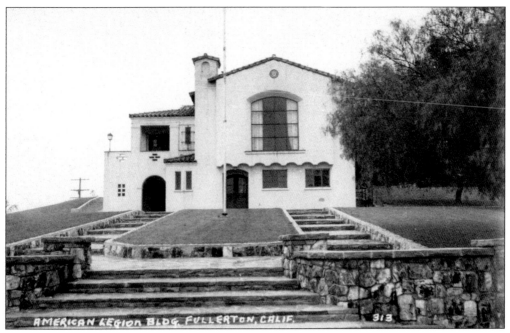

Situated on the corner of Valley View Drive and Lemon Street, the former American Legion Patriotic Hall, now the Hillcrest Park Recreation Center, was constructed in 1932 on land donated by the City of Fullerton in 1927. After the 1933 earthquake, the hall was used to feed and shelter frightened quake victims, many of whom set up camp in Hillcrest Park.

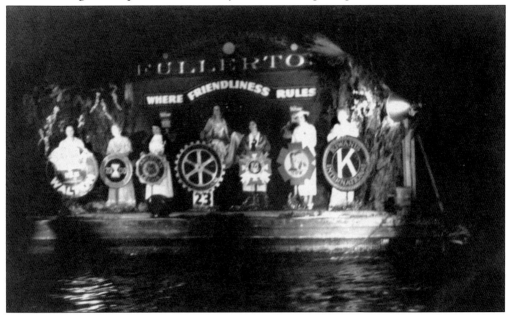

Taken at night, this photograph features Fullerton service clubs ("Where Friendliness Rules") honored during the city's Golden Jubilee Celebration in May 1937. From left to right, the service clubs are the Izaak Walton League, the 20-30 Club, the American Legion, the Rotary Club, Veterans of Foreign Wars, the Business and Professional Women's Club, and Kiwanis International.

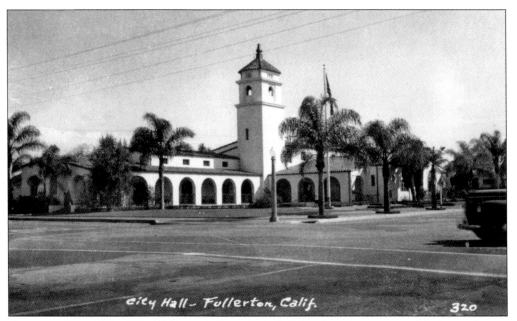

Constructed in 1939–1942, Fullerton's first city hall (237 West Commonwealth Avenue), now the Fullerton Police Department, was built by WPA workers at a cost of $132,507, making it one of the most costly structures erected during the Great Depression. The building served as Fullerton's first, full-fledged city hall until 1963, when a new city hall was completed down the street.

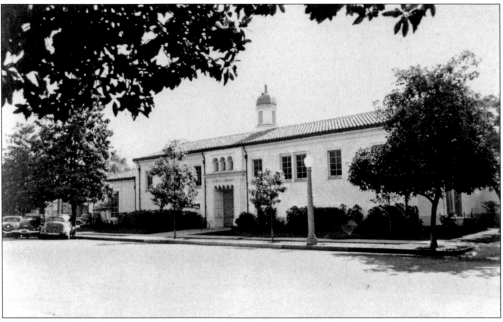

Shown in the 1940s is the WPA-built public library located on the northwest corner of Pomona and Wilshire Avenues. This structure, now the Fullerton Museum Center, replaced the 1907 Carnegie Library.

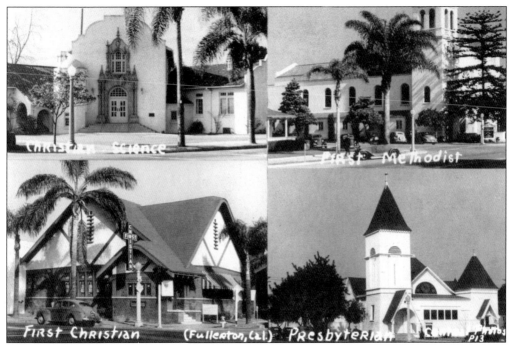

This 1947 postcard showcases four Fullerton churches. Pictured clockwise from the top left are the First Church of Christ Scientists (144 East Chapman Avenue), the First Methodist Church (201 East Commonwealth Avenue), the first Presbyterian Church (145 West Commonwealth Avenue, razed), and the First Christian Church (300 North Spadra Boulevard, razed).

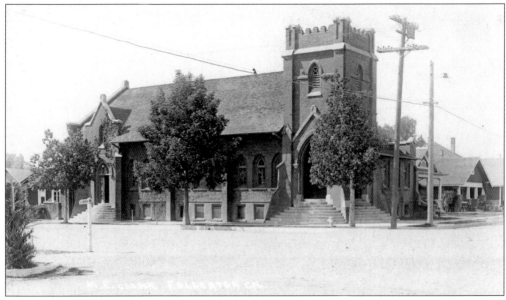

Fullerton installed electrical power in 1898, and the telephone poles shown in this postcard were already in place before the construction of the First Methodist Episcopal Church (117 North Pomona) in 1909. At the time, only eight percent of homes had telephones. The small building to the immediate right of the church at 142 East Amerige Avenue was constructed in 1905 and served as the parsonage for over 40 years.

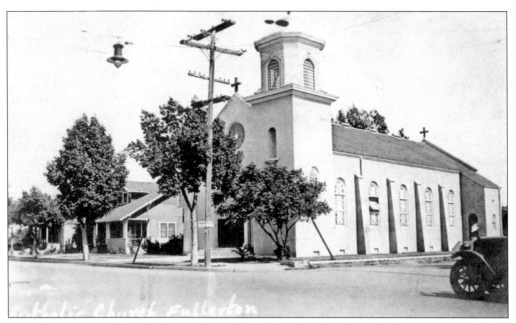

Named in honor of Maria Bastanchury (1848–1943), who donated the money needed to purchase the land, Santa Maria Church (later Saint Mary's), at 400 West Commonwealth Avenue, is shown in 1918. This Mission Revival building served as a religious center from 1912 to 1968, when it was destroyed by fire.

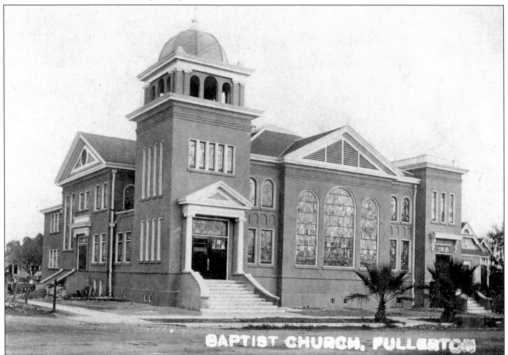

Mailed by Julia A. Censick on January 12, 1916, this snapshot features the First Baptist Church located in the 200 block of North Pomona. Constructed in 1912, the church was razed in 1967 to make way for a more modern building.

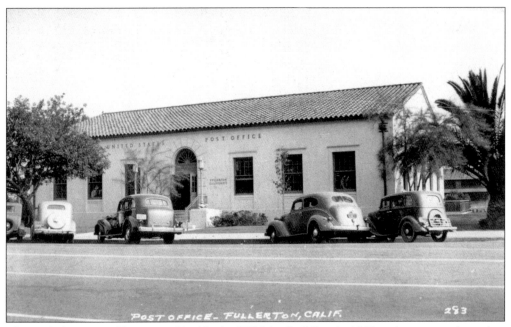

The city's first post office opened inside the Wilshire Building in 1888 and was moved to other locations in buildings throughout Fullerton. Using WPA funds, Fullerton constructed its first formal post office building in 1938, shown here, at 202 East Commonwealth Avenue. Tourist Annie Greason mailed this postcard to a friend in Colorado on September 12, 1946.

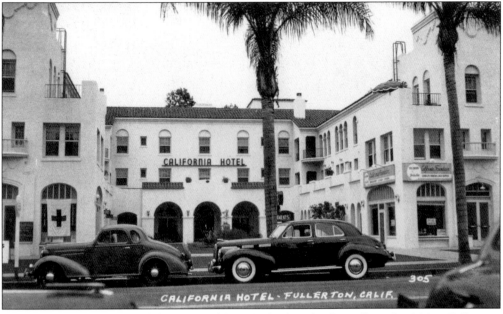

Shown in the 1940s is the California Hotel (1922), *the* place for the well-to-do visiting Fullerton. By the 1960s, the hotel was reduced to low-cost rental units. The three-story building was converted into small shops, restaurants, and offices and renamed Villa de Sol. The "U" shape was blocked off by a one-story wall that created an enclosed patio.

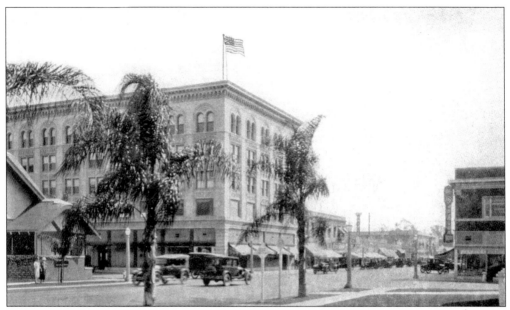

This 1920s postcard shows Spadra (Harbor) Boulevard facing south. The five-story Chapman Building (110 East Wilshire Avenue), constructed by Charles C. Chapman (1853–1944), is on the left. The small building in the left corner is Chapman's church, the First Christian Church (310 North Spadra) that was razed and replaced by a modern-styled structure.

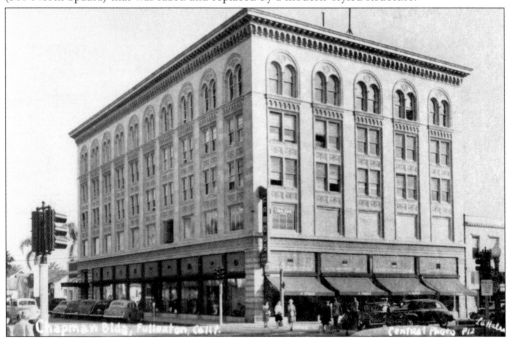

In 1923, Anaheim architect Eugene Durfee designed the five-story Chapman Building, shown in May 1948, for Charles C. Chapman, a well-known businessman and Fullerton's first mayor. Chapman began his entrepreneurial career in Chicago in the 1870s, and the building's Sullivanesque architectural style is based on the Chicago skyscraper designs of architectural genius Louis Sullivan (1856–1924).

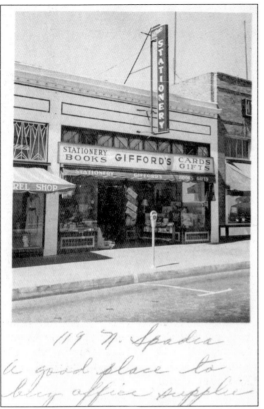

Gifford's Stationery opened its doors in 1945 and remained in the downtown area for decades. Owner Maurice H. Gifford (1893–1974) served in many local organizations in Fullerton during his years in business. The photograph taken for this postcard was too small to fill the card, so the remaining space was used to write additional information.

119 N. Spadra

a good place to buy office supplies

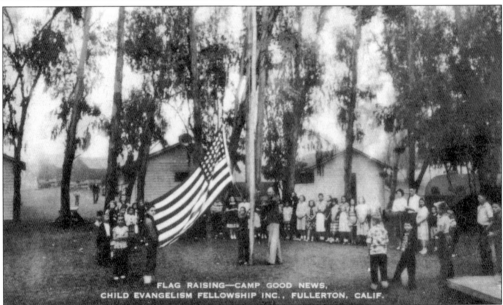

FLAG RAISING—CAMP GOOD NEWS,
CHILD EVANGELISM FELLOWSHIP INC., FULLERTON, CALIF.

This 1950s postcard features a flag raising at Camp Good News, a Christian camp sponsored by the Child Evangelism Fellowship (CEF). A worldwide organization, the CEF was founded by Jesse Irvine Overholtzer in 1937 with the purpose of evangelizing boys and girls with the gospel of Jesus Christ.

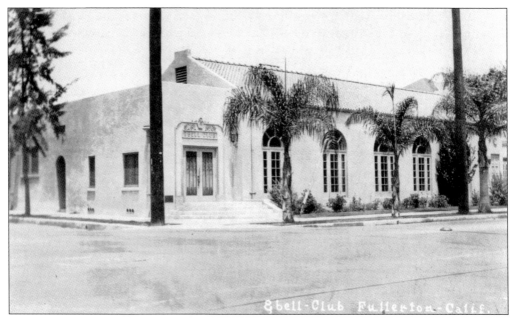

Chartered February 15, 1917, the Ebell Club, a women's cultural, social, and philanthropic organization, opened its first clubhouse, located on the northeast corner of Chapman Avenue and Lemon Street, in 1924. The organization later moved to 313 Laguna Road in 1962, and this clubhouse was razed. The 1924 clubhouse was designed by Santa Ana architect Fay R. Spangler, one of the few women working in the field at the time.

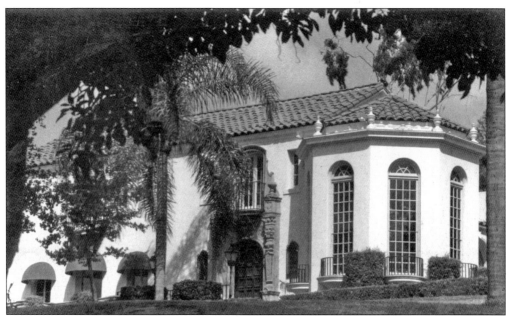

Taken in the 1980s, this postcard features the 7,600-square-foot Muckenthaler Cultural Center at 1201 West Malvern Avenue, donated by the Muckenthaler family to the City of Fullerton in 1965.

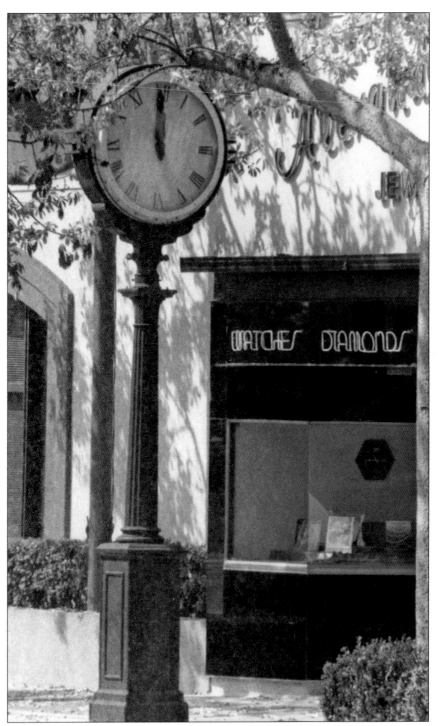

Also taken in the 1980s, this snapshot shows the half-ton Stedman Clock, a local landmark, in front of Alexander's Jewelers at 109 North Harbor Boulevard. The clock was originally installed in 1910 at 110 North Spadra Boulevard but was moved across the street in 1940 when William Stedman relocated his business.

Four

GERMAN POSTCARDS

By the end of the 19th century, Germany had developed new printing and lithography techniques that enabled printers to produce high-quality postcards at affordable prices. The deluxe postal cards they produced were simply the best in the world, and Germany exported millions of postcards each year, more than any other country. German printers excelled at hand tinting and embossing, and their greeting cards in particular, known for their heavy gilding and lavishness, were highly desired by collectors then and now. Around 1906, Fullerton residents and business owners, such as William Starbuck (Gem Pharmacy) and Gus Leander (Scobie and Leander), started mailing black-and-white photographs to Germany to be turned into hand-tinted postcards. The photographs would be mailed directly to German printers or, more conveniently, sent to postcard publishers in Los Angeles—M. Reidel Publishing; Woods, Inc.; and the Newman Post Card Company—who in turn would mail them to Germany with printing instructions. German-produced postcards of Fullerton are some of the most beautiful cards ever printed. World War I ended German exports of postcards, and Fullerton residents and businessmen looked instead to American printers. By the 1920s, nearly all Fullerton postcards were produced in the United States.

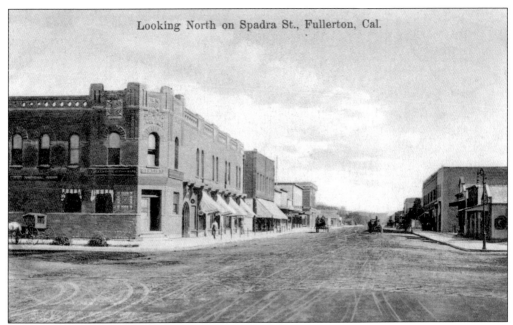

Looking North on Spadra St., Fullerton, Cal.

Taken around 1910, this is Spadra Boulevard looking north from Commonwealth Avenue. One of the first buildings in town, Chadbourne Hall (1888), built, owned, and named for Caroline Chadbourne of San Francisco, is on the left. The first floor housed retail businesses; the second floor contained offices and a large hall for meetings and entertainment.

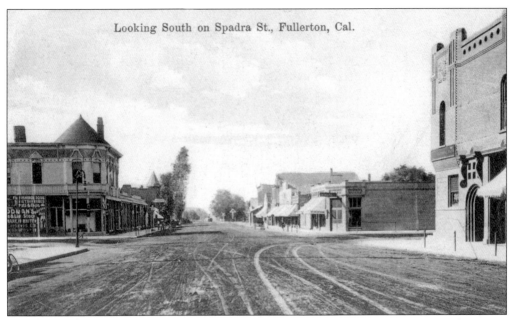

Looking South on Spadra St., Fullerton, Cal.

This is Spadra Boulevard looking south around 1910. On the left is the 17,000-square-foot Stern and Goodman Department Store (1889), the largest department store in Orange County at the time. Owners Jacob Stern (1859–1934) and Joseph Goodman opened additional merchandising businesses in nearby towns, expanding to become one of the first chain stores in the state.

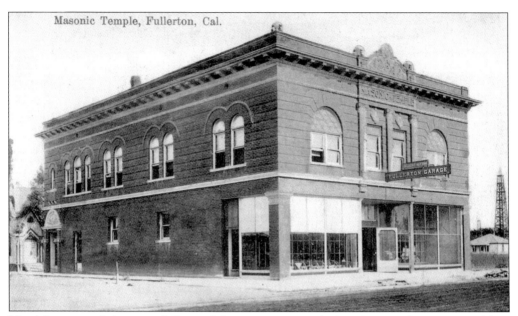

The Masons used the second floor of the Masonic Temple (1901), now the Porter Building at 201 North Harbor Boulevard, until the organization moved into a larger facility on the northwest corner of Harbor Boulevard and Chapman Avenue. Albert Sitton (1878–1967), the town's first auto repairman and electrician, owned the Fullerton Garage on the east side.

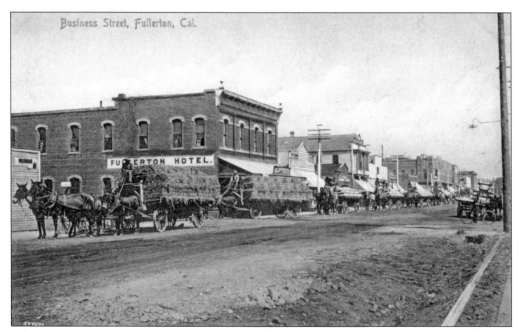

Taken in 1910, this postcard shows a wagon train of hay and grain on the way to the train station for shipment.

These two postcards, both from 1911, feature residential streets in downtown Fullerton.

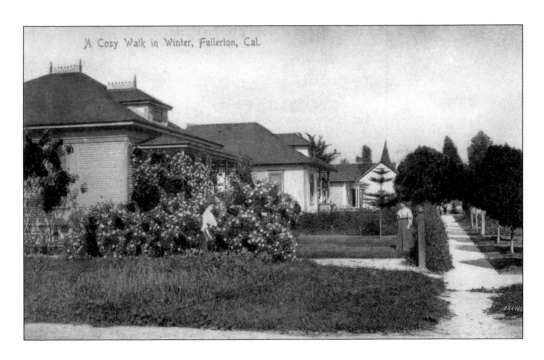

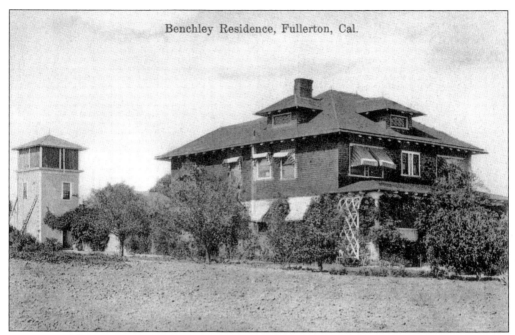

Benchley Residence, Fullerton, Cal.

L. B. Benchley (1822–1906), the founder of Pacific Roller Mills, made his millions in San Francisco and then moved to Fullerton, where he purchased a 140-acre walnut grove (Helena Orchards) in 1885 for $50,000. At the rear of his ranch residence is a water tower.

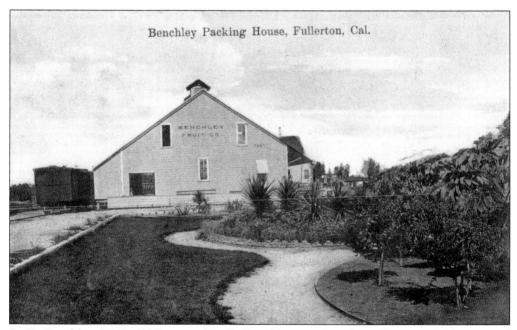

Benchley Packing House, Fullerton, Cal.

E. K. Benchley (1854–1924), son of L. B. Benchley, purchased a walnut grove in 1900 and two years later organized the Benchley Fruit Company, which quickly became a major packer and shipper of oranges, walnuts, and lemons. By 1909, Benchley's business was averaging 175 train cars of fruit a year ($150,000). On June 4, 1916, a fire destroyed this packinghouse, shown in 1909.

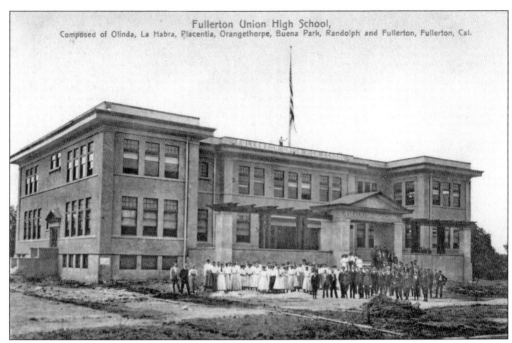

Students stand in front of Fullerton Union High School around 1908. Located on Commonwealth Avenue, the high school burned to the ground in 1910, and it relocated to Chapman Avenue.

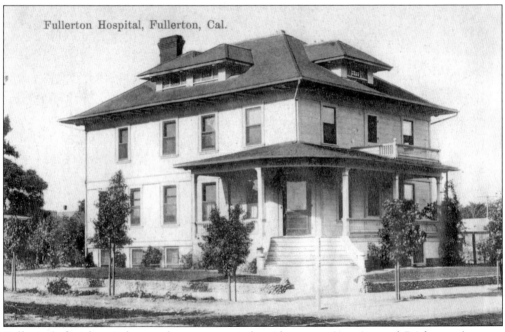

Fullerton's first hospital was a large, converted residence on Amerige and Richman Avenues that quickly proved inadequate. An association of doctors and businessmen was formed to build this mansion-like, wood-framed second hospital in 1903 at a cost of $6,700. At the time, Fullerton only had around 1,000 residents. Another general hospital was later built in 1913.

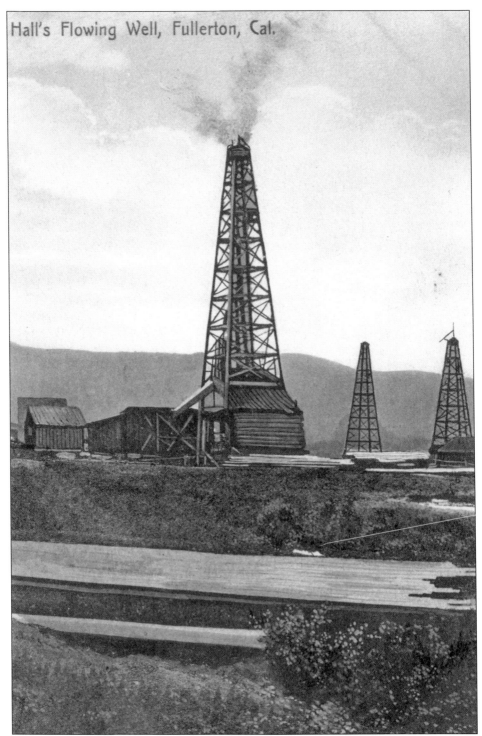

Hall's Flowing Well, Fullerton, Cal.

On July 1, 1899, workers struck oil in Hall's well in the Fullerton district at 1,360 feet, pumping out 80 barrels a day. This 1910 postcard was mailed from a son to his mother in Wellsville, Kansas, with the short note: "Am well. Still Alive. Your son, R.J.R."

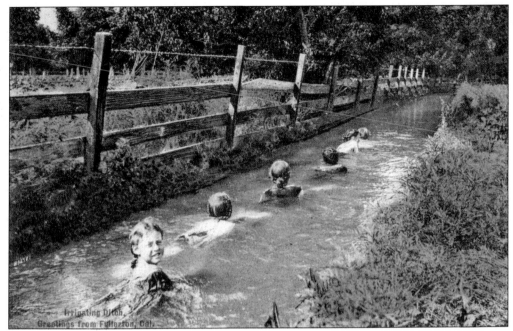

Like many postcards printed during the era, this 1910 photograph of children swimming in an irrigation ditch was used for promotional purposes. Eager to attract more settlers, local residents showcased Fullerton as a good place to raise children and a town where water was plentiful for farming.

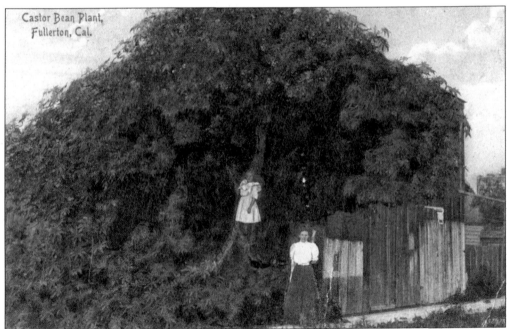

Mailed in 1912, this postcard showcases a gigantic castor tree in front of a Fullerton residence. The woman in the foreground is reportedly Candy White, the wife of an orange packer.

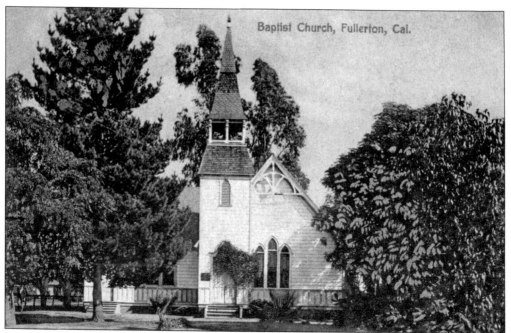

Baptist Church, Fullerton, Cal.

The Presbyterian church was established February 19, 1888, at a meeting in the dining room of the St. George Hotel. A year later, this first church, located at the corner of Pomona and Wilshire Avenues, was constructed by contractor Thomas S. Grimshaw (1852–1929) at a cost of $2,130 plus $125 for a fence, outhouse, hitching post, and ornamentation. When the congregation could no longer afford the church, the Baptists purchased it in 1893.

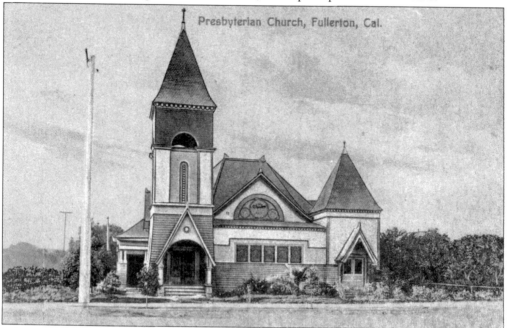

Presbyterian Church, Fullerton, Cal.

After increasing membership in their congregation, the Presbyterians built this second church, dedicated October 14, 1900, and located on the northeast corner of Malden and West Commonwealth Avenues. The church was razed in 1955.

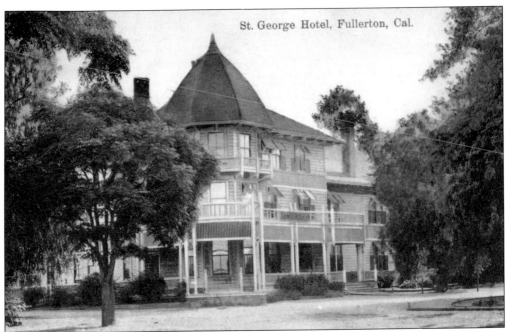

St. George Hotel, Fullerton, Cal.

Constructed in 1888 by town founders George and Edward Amerige in an effort to support city development, the St. George Hotel was located on what is now the northeast corner of Harbor Boulevard and Commonwealth Avenue. Townspeople donated the plants and trees shown. The fashionable, dark-brown redwood hotel, demolished in 1918, had 65 lavishly appointed rooms but only two bathrooms.

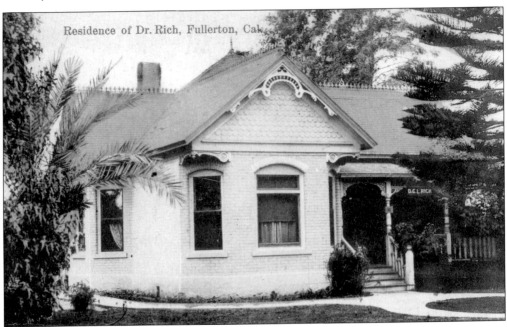

Residence of Dr. Rich, Fullerton, Cal.

Dr. Clayton L. Rich (1873–1911) used this building at 208–210 West Commonwealth Avenue as his home and office while practicing medicine from 1897 until his untimely death in 1911. Rich also served as Fullerton city health officer.

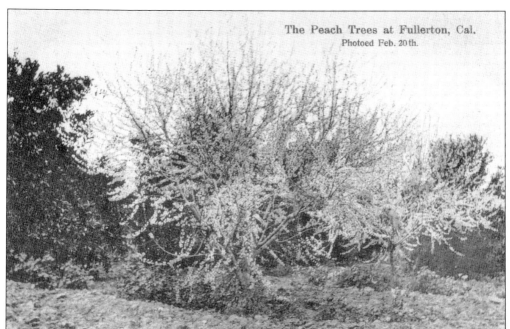

The Peach Trees at Fullerton, Cal.
Photoed Feb. 20th.

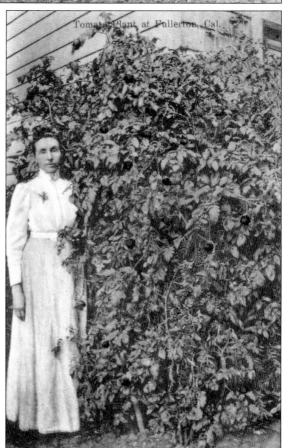

Tomato Plant at Fullerton, Cal.

In 1909, Civil War veteran Thomas H. White, who owned a candy factory in Fullerton, dropped these photographs off to the Newman Post Card Company (610 South Broadway) in Los Angeles, which then mailed them to Germany to be hand colored and printed. The above postcard of a peach tree was taken February 20, 1909. In the postcard to the right, Susie J. White sent this picture of herself standing next to a tomato bush to her niece with the message, "I send you a card with my picture on to help keep you from forgetting me."

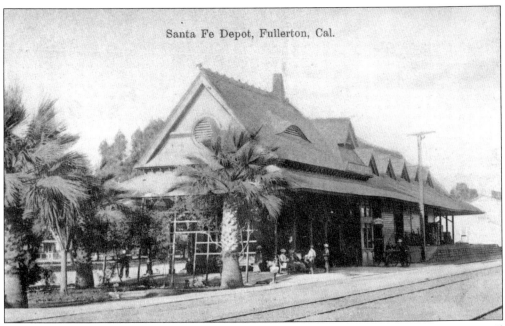

Santa Fe Depot, Fullerton, Cal.

A Fullerton visitor mailed this postcard of the Santa Fe Depot to her sister in Missouri on April 4, 1910. She notes on the back that this is "a typical depot of Southern California."

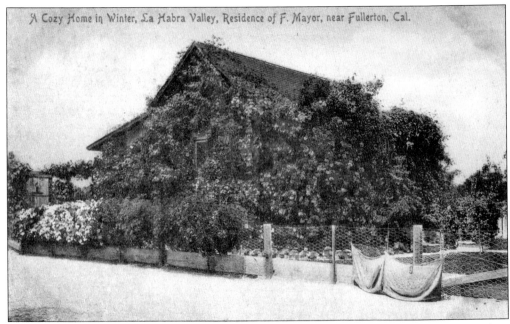

A Cozy Home in Winter, La Habra Valley, Residence of F. Mayor, near Fullerton, Cal.

This 1910 postcard showcases the home of a local resident named F. Mayor in what was then north Fullerton. Starting in the early 1900s, La Habra Valley was used to describe the area between East Whittier and Yorba Linda.

Five

Photochromes or Souvenir Postcards

In 1939, the Union Oil Company launched the photochrome (or chrome) postcard in their western service stations. These new postcards were easily produced, of high photographic quality, and, most importantly, were in bright color. Printed on paper with a shiny surface, photochromes are not real photographs but are printed cards done by a photochrome process. This new printing process immediately captured the fancy of Americans and chromes quickly replaced linen and black-and-white cards in postcard racks. World War II momentarily stopped their distribution because of supply shortages, but by 1945, chromes were the dominant postcard produced throughout the United States. They are now the easily recognizable postcards that tourists around the world purchase while on vacation. The first chromes were 3 by 5 inches, but by the 1960s, the standard size of postcards had grown to 4 by 6 inches. Unlike real-photo postcards, souvenir chromes are mass-produced views of main streets and well-known attractions in larger towns and cities, overshadowing the individual people and events that gave the earlier, real-photo postcards their intimacy and immediacy.

This is a generic tourist postcard from the 1960s.

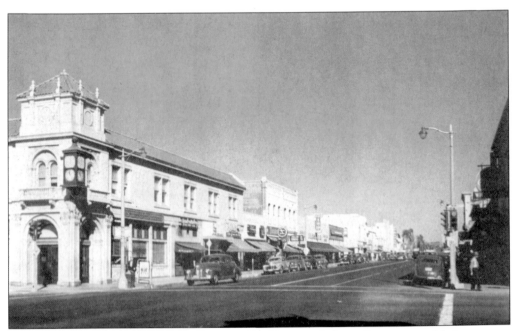

This 1940s postcard shows Harbor Boulevard looking north from Commonwealth Avenue.

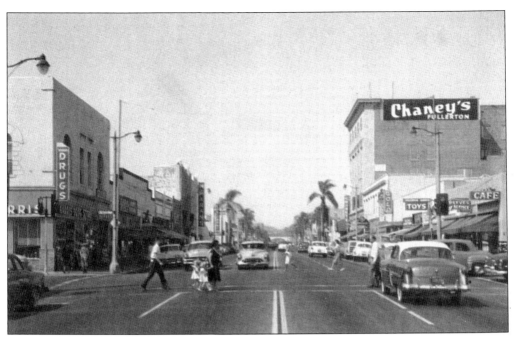

This 1950s postcard is looking north on Harbor Boulevard from Amerige Avenue.

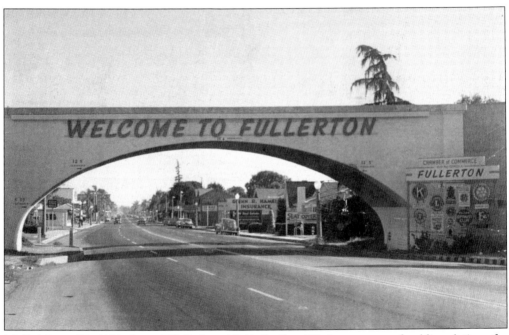

Mailed June 25, 1959, from Bill Dalton (1841 Skyline Way), manager of public relations for the Fullerton Chamber of Commerce, to Allan H. Butler (1300 Valley Vista Drive), assistant superintendent of the Fullerton School District (1954–1972), this tourist postcard features the Pacific Electric Railroad viaduct (1917) spanning Harbor Boulevard at the northern entrance to the city. The viaduct was razed in 1964.

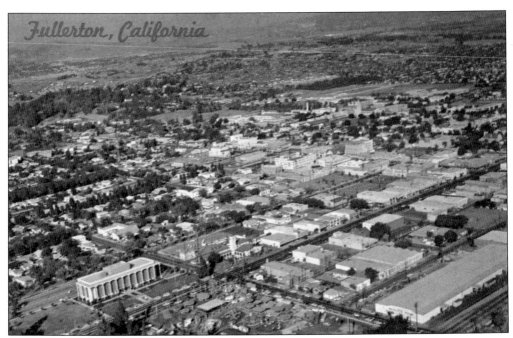

This typical souvenir postcard is an aerial photograph of Fullerton in 1965. Fullerton's new city hall (303 West Commonwealth Avenue), dedicated June 2, 1963, is in the bottom left.

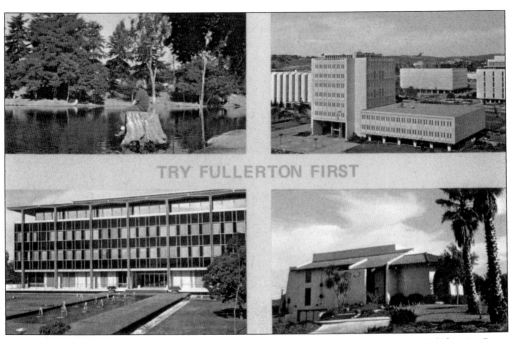

This 1960s postcard features, clockwise from the top left, Laguna Lake, California State University, Fullerton, a residence at 750 Santa Barbara Avenue, and the corporate office building (1963) of Hunt Foods and Industry (later Hunt-Wesson Foods), designed by notable architect William Pereira. The back of the postcard notes: "Fullerton, California is a unique city with the finest in living . . . Recreation, Education, Employment and Living."

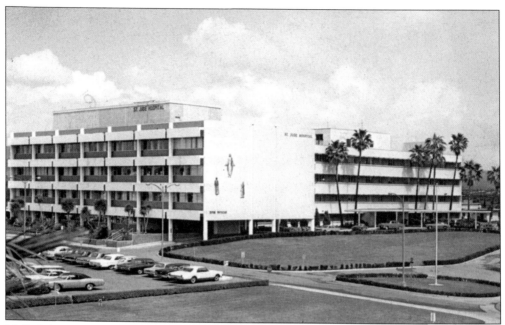

Mailed August 17, 1970, this postcard features St. Jude Hospital. Operated by the Sisters of St. Joseph of Orange, the hospital originally opened in 1957, added a new wing in 1962, and is undergoing additional expansion in 2007. The postcard notes that it is "one of the most modern hospitals on the West Coast."

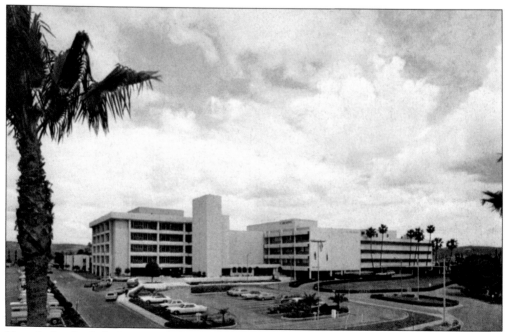

Here is the St. Jude Hospital and Rehabilitation Center, located at 101 East Valencia Mesa Drive, in 1977. Professional photographer Roland Hiltscher, who for over 45 years documented people, places, and events in Fullerton, took this snapshot.

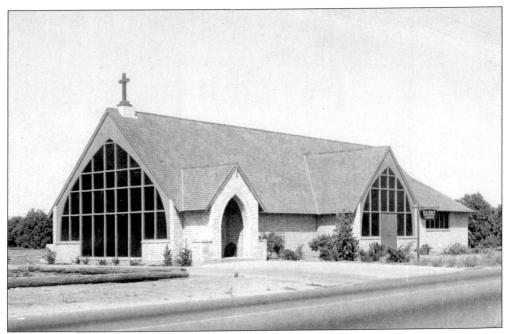

Dedicated in 1953, this is Saint Andrew's Episcopal Church at 1231 East Chapman Avenue. The first Episcopal church building, constructed in 1923, was located at 226 West Amerige Avenue.

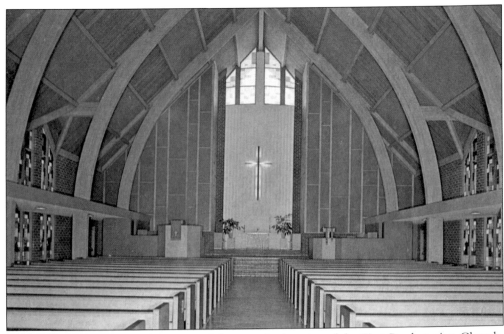

Taken in the early 1960s, this postcard features the interior of the First Presbyterian Church, located at 838 North Nicholas (now Euclid) Avenue.

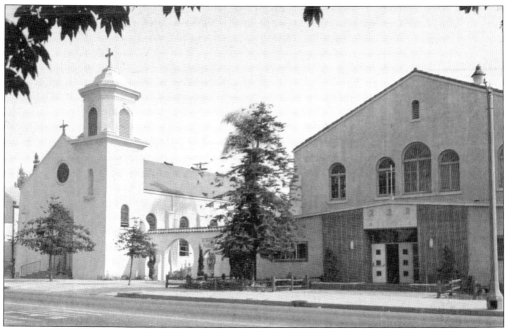

Taken in the 1950s, this photochrome features St. Mary's Parish and School at 400 West Commonwealth Avenue. At that time, there were 120 students registered in the first grade attending St. Mary's School in two shifts.

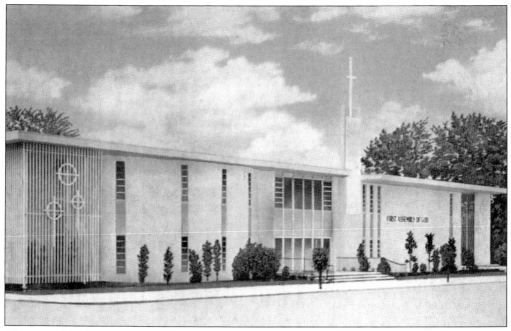

This snapshot features the First Assembly of God Church (404 W. Wilshire Avenue), which was constructed in the 1960s and now known as the Christian Life Center.

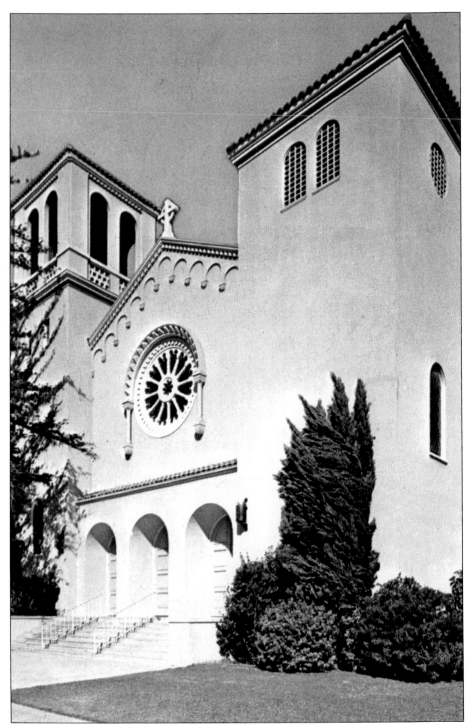

This postcard features the First Methodist Church at 201 East Commonwealth Avenue. James Edward Allison and David Clark Allison (Allison and Allison) designed the church in 1929. The pair is well known throughout California for their school architecture, most notably for the beautifully designed buildings on the University of California, Los Angeles (UCLA) campus.

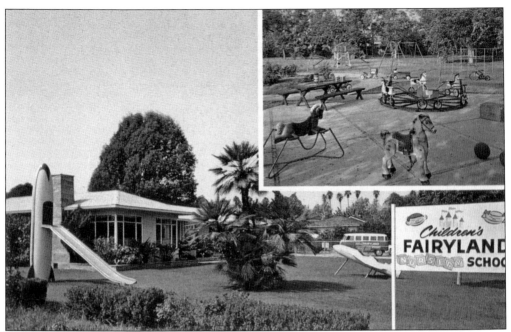

Children's Fairyland Nursery School, Inc., which started in Orange County in 1953, had one school in Anaheim (1597 West Katella Avenue) and two in Fullerton (3401 Harbor Boulevard and 234 East Commonwealth Avenue).

This postcard was produced shortly after Raymond Avenue School opened in 1953. The elementary school was constructed after record-breaking growth on the east side of the city.

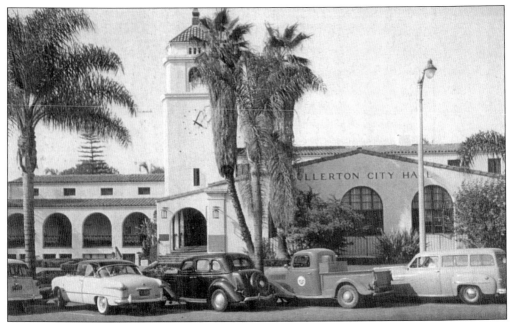

Mailed May 25, 1956, this photochrome features an exterior shot of the Fullerton City Hall, located at 237 West Commonwealth Avenue, which is now the police department.

Dedicated in 1954, this is the Boys Club of Fullerton at 348 West Commonwealth Avenue. In 1988, girls joined the organization, and it was renamed the Boys and Girls Club of Fullerton.

This postcard features the lily pond and reflection pool in Amerige Park, just off Commonwealth Avenue, in the 1950s.

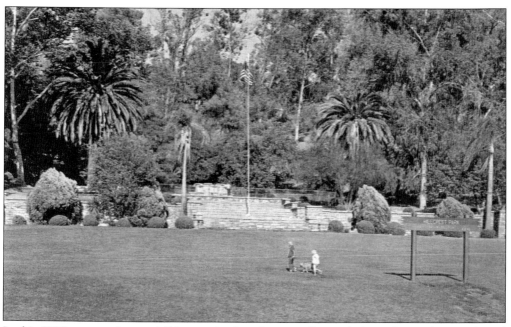

In this 1960s postcard, two children and a dog play in Hillcrest Park on the Harbor Boulevard side. At the top of the flagstone steps is the electrically run water fountain, constructed in 1936 by WPA laborers at a cost of $20,000. The fountain delighted Fullerton residents for decades until it was turned into a planter in the 1970s. (Courtesy of Jorice Maag.)

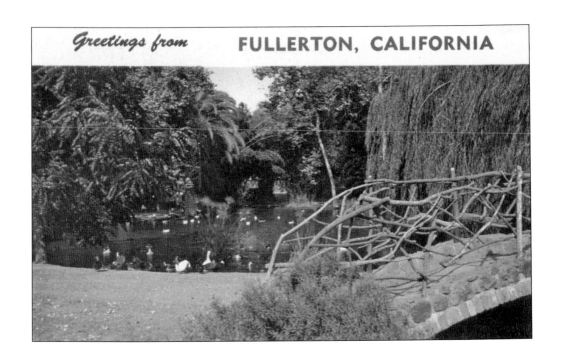

Greetings from **FULLERTON, CALIFORNIA**

Taken in the 1950s, these two postcards feature the popular duck pond in Hillcrest Park, situated east of Harbor Boulevard and south of Brea Boulevard.

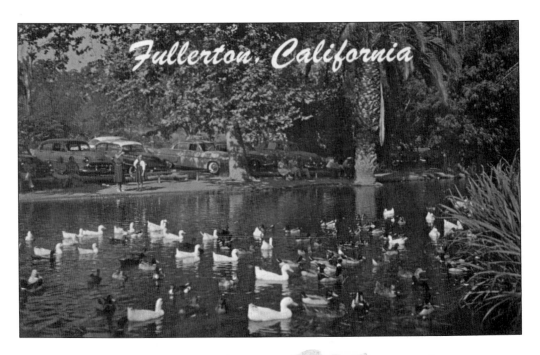

Fullerton, California

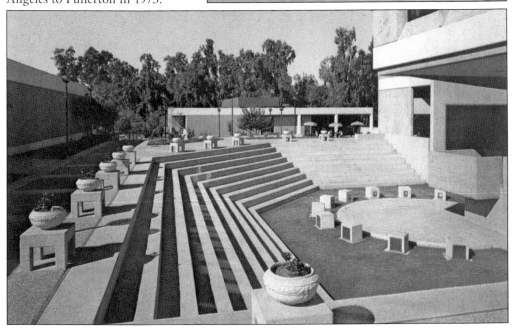

Fullerton now has five colleges and universities, and these educational facilities have remained perennial favorites for photochrome postcards. These two postcards feature the Southern California College of Optometry at 2575 Yorba Linda Boulevard. The postcard to the right shows the Roger C. Wilson Administration Building, while the one below displays the Ernest A. Hutchinson Memorial Amphitheater. The college moved from Los Angeles to Fullerton in 1973.

This postcard features the Administration Building (the 100 Building) on the Fullerton College campus. This photochrome was taken in the 1950s from Chapman Avenue before an addition was added to the building and a remodel altered its exterior.

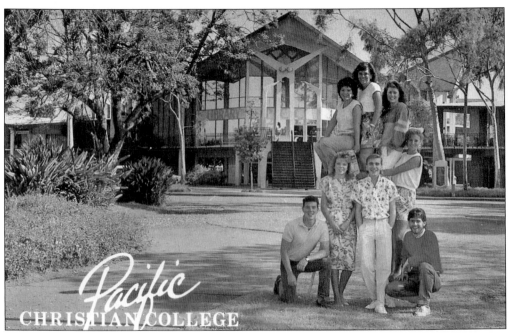

In this postcard, students stand in front of the library of Pacific Christian College (PCC), located at 2500 East Nutwood Avenue, the traditional undergraduate school of Hope International University and one of three schools that make up the university. PCC opened in 1975.

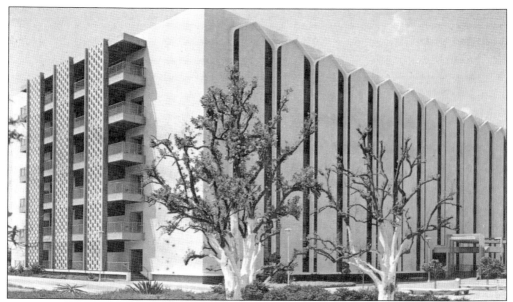

The first major structure to be built on the 230-acre California State University, Fullerton (CSUF) campus, the six-story Letters and Science Building was dedicated on October 11, 1963. It was renamed McCarthy Hall on September 21, 1984, in honor of Dr. Miles McCarthy, who for decades served as a mentor to pre-med students. The campus opened as Orange County State College in September 1959.

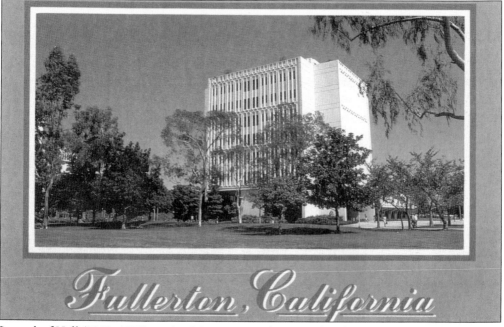

Langsdorf Hall (1969–1971) on the CSUF campus has served as the Administration and School of Business Administration Building. The structure was named for the founding president of CSUF, Dr. William B. Langsdorf (1909–2002). When founded, CSUF became the 12th state college in California to be authorized by the legislature. Before Langsdorf Hall was completed, administrative offices were housed on the Fullerton Union High School campus.

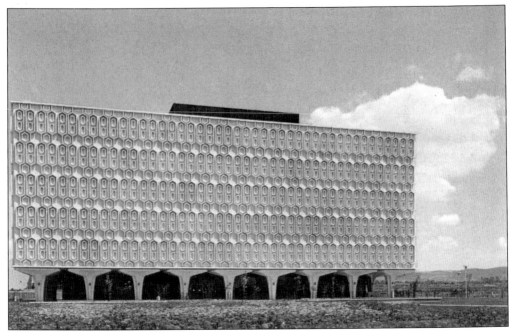

Dedicated on November 30, 1966, this is the CSUF Library and Audio-Visual Building, now the Paulina June and George Pollak Library, the fourth permanent building on the campus. In 1996, an architecturally incompatible wing (Library North) was added to the library, providing four new floors.

The College Commons (1966–1967) was the focal point for food on the CSUF campus but now serves as the campus bookstore.

CALIFORNIA STATE UNIVERSITY
FULLERTON

This current postcard features Center Plaza on the CSUF campus. (©Photografx Worldwide, LLC.)

Opened on March 21, 2006, this is the $2.28-million Orange County Agricultural and Nikkei Heritage Museum at the Fullerton Arboretum. The 8,537-square-foot facility is the first environmentally friendly green project on the CSUF campus. (Courtesy of Jorice Maag.)

FULLERTON ARBORETUM

ANNIVERSARY

25

1979-2004

Taken in celebration of the 25th anniversary of the Fullerton Arboretum, this postcard features the Dr. George Clark House and Office (1894), which was moved to the Fullerton Arboretum from its original location at 114 North Lemon in 1972. (Courtesy of Jorice Maag.)

Six

Novelty and Specialty Postcards

The craze for novelty postcards ran from 1901 to 1910. Novelty postcards included mechanical cards, postcards with something stuck on them, cards made of unusual or oddball materials, or oddly shaped or sized cards (midget, giant, and bookmark sizes). Mechanical cards required some sort of action by the purchaser or recipient: the pulling of a lever, the rolling up or down of blinds, or the rotating of wheels. Gimmicky postcards were mailed with what seemed like a never-ending variety of materials, including bags of salt, human hair, coins, pressed flowers, feathers, ribbons, and colored glass designed to resemble jewels. Some novelty cards were die-cut shapes or had holes in which fingers could be inserted to make postcard figures appear to have real arms, legs, or even a nose. Americans invented the leather and wooden postcard, and were also particularly fond of the humorous tall-tale postcard, which had exaggerated fantastical images, such as a fisherman catching an oversized fish. Not to be left out, a French syndicate developed a singing postcard in 1904 by inventing a process by which a transparent gelatine disk could be affixed to a postcard and then played on a gramophone. Many novelty postcards were cheap and tacky but wildly popular. When postal regulations were changed to require that the cards be placed in sealed envelopes or protective boxes before mailing, the fad for this type of postcard faded. Fullerton residents were particularly fond of leather postcards, and over the years produced some odd and specialized postcards.

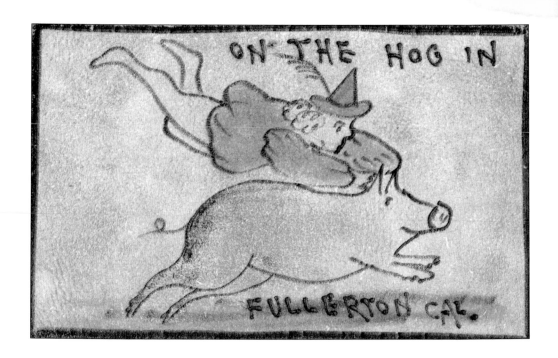

These are two handmade leather postcards dating from 1908. Images were often burned or painted onto the surface. When the federal government required that postcards made from unusual materials, including wood, metal, and even Japanese bamboo, be mailed in envelopes, the leather postcard quickly lost favor. Unlike the penny picture postcard, leather cards sold for 5–10¢ each.

Mailed July 6, 1908, this leather postcard was most likely made by a student at Fullerton High School.

M. Rieder Publishing in Los Angeles made this leather postcard. Michael Rieder's company, located at 234 New High Street, specialized in view books and postal cards and was popular with Fullerton residents, who often sent their photographs to the company to turn into postcards.

To create this unique result, someone took a blank postcard and glued leather four-leaf clovers on the front and then hand-lettered "Good Luck, Fullerton Cal." At the time, stationery and novelty stores sold stencils and other materials for amateur artists to produce their own postcards.

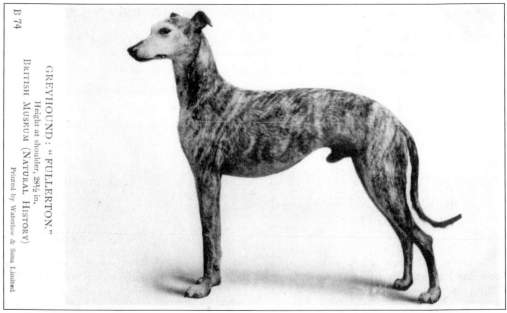

Considered the greatest coursing greyhound in British history, Fullerton, a 65-pound brindle, won the English Waterloo Cup—the most valuable of all coursing events—an amazing four times: 1889, 1890, 1891, and 1892. Col. J. T. North, known as the "Nitrate King" for the massive fortune he amassed from the nitrate fields of South America, purchased Fullerton, then a 20-month puppy, for an astounding 850 guineas in 1888.

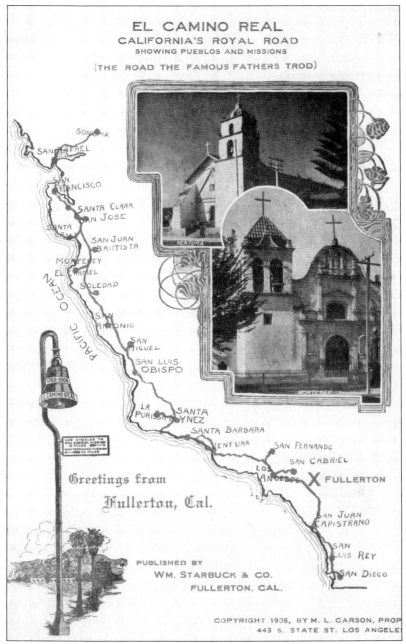

EL CAMINO REAL

CALIFORNIA'S ROYAL ROAD
SHOWING PUEBLOS AND MISSIONS

(THE ROAD THE FAMOUS FATHERS TROD)

Greetings from
Fullerton, Cal.

PUBLISHED BY
WM. STARBUCK & CO.
FULLERTON, CAL.

COPYRIGHT 1906, BY M. L. CARSON, PROP
443 S. STATE ST. LOS ANGELE?

This lovely 1906 postcard, published by William Starbuck and Company, was designed to showcase Fullerton as a stop along El Camino Real (the Royal Road), which connected the California missions. William Starbuck (1864–1941) and his wife, Flora, moved to Fullerton in 1888, where they promptly became involved in the development of the town. The couple opened Fullerton's first drugstore, the Gem Pharmacy, which became a center of community activity. Starbuck saw the need for postcards to both sell and promote the fledgling town site. Around 1905, he began publishing postcards, rapidly becoming the most prolific publisher of postcards in Fullerton. On occasion, he would send photographs to publishers in Chicago, Los Angeles, and Germany to be turned into postcards that he would sell at his drugstore.

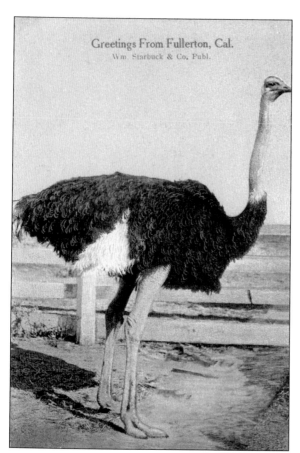

Greetings From Fullerton, Cal.
Wm. Starbuck & Co. Publ.

After opening his drugstore, William Starbuck noticed that there were no Fullerton postcards available to sell. To fill the gap, he quickly produced a series of "Greetings from Fullerton" postcards that featured locations other than Fullerton. Those unfamiliar with the town or California would often mistakenly believe that they were looking at a picture of Fullerton. Fullerton had an ostrich farm, but the card at left features a bird from Pasadena. Although walnuts were the main crop in Fullerton before being replaced by citrus fruits, the postcard below, mailed on April 5, 1906, by Sue L. Sheppard (337 East Chapman Avenue), is not of a Fullerton walnut grove.

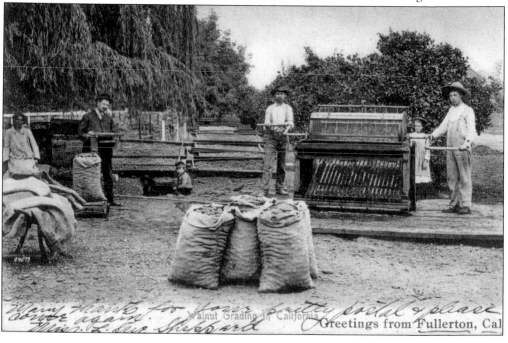

Walnut Grading in California

Greetings from Fullerton, Cal

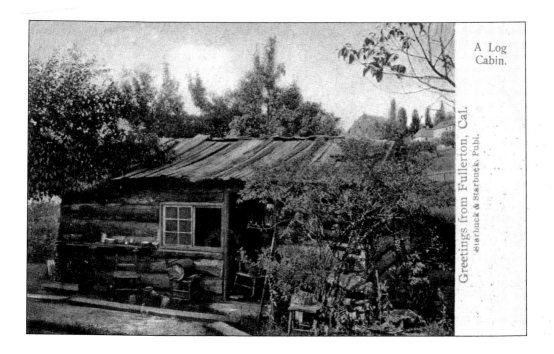

A Log Cabin.

Greetings from Fullerton, Cal.
Starbuck & Starbuck, Pub.

Also published by William Starbuck as part of his "Greetings from Fullerton" series, these two postcards feature unidentified locations outside Fullerton.

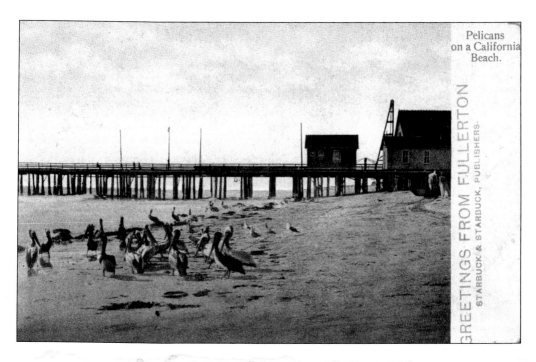

Pelicans on a California Beach.

GREETINGS FROM FULLERTON
STARBUCK & STARBUCK, PUBLISHERS.

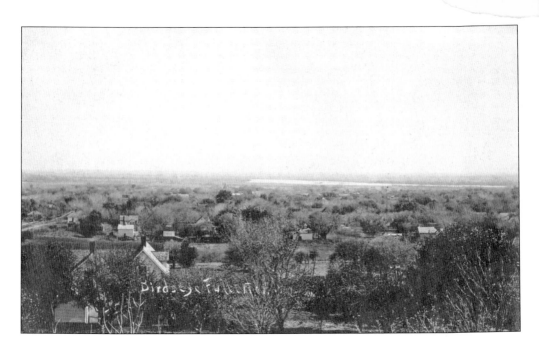

With the Kodak Folding Camera, amateur and professional photographers could write the name of the street, town, or homeowner on the negative, making it a permanent part of the photograph. Quite often though, the information was incomplete or incorrect, forcing postcard collectors to be alert when purchasing cards from dealers. The above postcard notes "Birdseye Fullerton" on the front, but the snapshot is most likely of Fullerton, Nebraska. The postcard below is a of street named Fullerton not within the boundaries of Fullerton, California, which never had a row house as a building type.

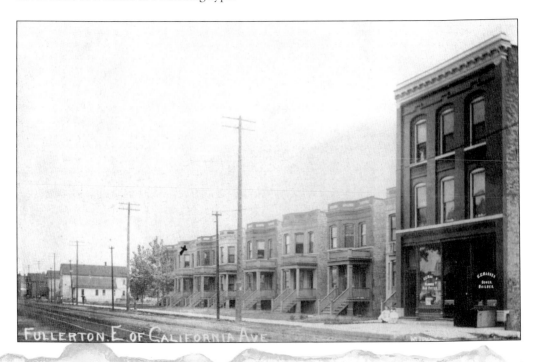

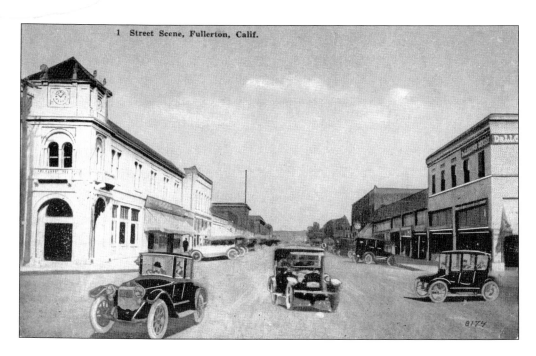

1 Street Scene, Fullerton, Calif.

After opening its doors in Los Angeles at 406 South Los Angeles Street in 1919, the M. Kashower Company produced a series of postcards of well-known sites in Fullerton. To enhance the photographs, an employee of the publishing firm inserted hokey-looking automobiles into each scene. The above postcard features Spadra (now Harbor) Boulevard looking north from Commonwealth Avenue. The postcard below shows the same cars in front of Fullerton Union High School. Printers often updated popular postcards by substituting motor vehicles for horse-drawn ones.

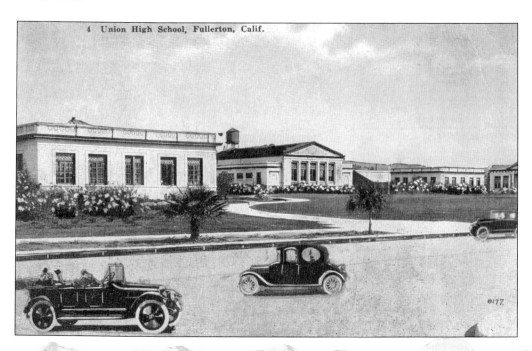

4 Union High School, Fullerton, Calif.

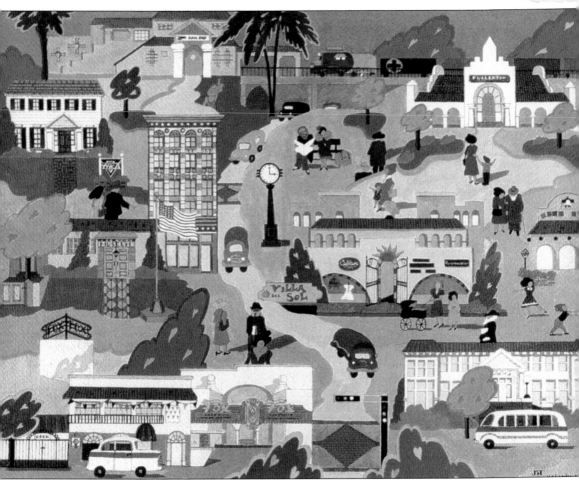

In 1983, illustrator and water colorist Judy Smith Transport won a city-sponsored contest to design a poster that would reflect Fullerton's character. This postcard is based on the winning poster, "Fullerton, A Great Place To Be."

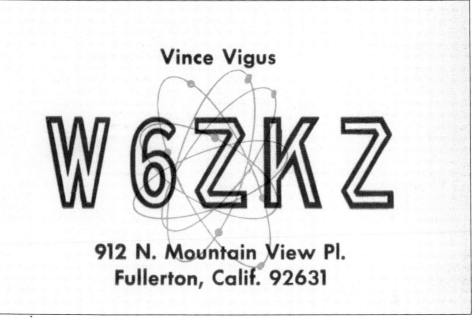

Vince Vigus

W6ZKZ

912 N. Mountain View Pl.
Fullerton, Calif. 92631

Citizens' band (CB) and Ham radio operators use QSL cards to confirm communications between stations. QSL cards are named for the Q code "QSL," which means "I acknowledge receipt" or "I confirm contact with you." This is the QSL postcard for Vince Vigus, who was a Ham radio operator for over 30 years.

WRL-Print

WN6RUP

Bill Heise—1113 No. Stanford Ave., Fullerton, Calif.

MY QTH

RADIO *W0MEF*
CONF. QSO OF *10-17* 195*8*
AT *2125* A.M. *P* ST
UR *2904* MC. FONE SIGS RST *Q-5-10ovv* *100% copy*
XMTR *PX 35* RECVR *SX 101*
REMARKS: *ONE OF THE BEST OF THE BETTER QSO's, Roy,* *73 Bill*
SEE U
N CAL,

This QSL postcard belonged to Bill Heise (1113 North Stanford Avenue). The front of the postcard shows some of the information exchanged by amateur radio operators after they had connected with each other. QSL cards, which have been around since the early 1900s, are often collected as a hobby.

These are two additional QSL cards of Fullerton residents: Archie R. Ellis (top) and John G. Cropsey (bottom).

Still in

Fullerton

Waiting and waiting,
and waiting some more;
But each time the letter-man
passes my door.

These two generic cards were designed so that sellers could stamp or print the names of different locations on them and thereby sell them anywhere in the United States. The postcard to the right also left room at the top, where a small photograph (in this case the 1907 Carnegie Library) could be glued on.

Will be glad to see you in

Fullerton

The finest little town on the map

Across America, People are Discovering Something Wonderful. *Their Heritage.*

Arcadia Publishing is the leading local history publisher in the United States. With more than 3,000 titles in print and hundreds of new titles released every year, Arcadia has extensive specialized experience chronicling the history of communities and celebrating America's hidden stories, bringing to life the people, places, and events from the past. To discover the history of other communities across the nation, please visit:

www.arcadiapublishing.com

Customized search tools allow you to find regional history books about the town where you grew up, the cities where your friends and family live, the town where your parents met, or even that retirement spot you've been dreaming about.